A Box of Photographs

A Box of Photographs

ROGER GRENIER

Translated by Alice Kaplan

THE UNIVERSITY OF CHICAGO PRESS *Chicago and London*

ROGER GRENIER, an editor at Éditions Gallimard, has published over thirty novels, short stories, and literary essays, including *The Difficulty of Being a Dog*, also published by the University of Chicago Press. He is the recipient of the Grand Prix de Littérature de l'Académie Française, among numerous other prizes.

ALICE KAPLAN is the author of several books, including *French Lessons: A Memoir* and *Dreaming in French: The Paris Years of Jacqueline Bouvier Kennedy, Susan Sontag, and Angela Davis*, and the translator of *The Difficulty of Being a Dog*. Her books have been twice nominated for the National Book Critics Circle Awards, once for the National Book Award, and she is a winner of the *Los Angeles Times* Book Prize. She holds the John M. Musser chair in French literature at Yale.

The University of Chicago Press, Chicago 60637
The University of Chicago Press, Ltd., London
© 2013 by The University of Chicago
All rights reserved. Published 2013.
Printed in the United States of America

22 21 20 19 18 17 16 15 14 13 1 2 3 4 5
ISBN-13: 978-0-226-30831-9 (cloth)
ISBN-10: 0-226-30831-6 (cloth)

Originally published as *Dans le secret d'une photo*, © Éditions Gallimard, Paris, 2010.

Cet ouvrage a bénéficié du soutien des Programmes d'aide à la publication de l'Institut français. This work, published as part of a program of aid for publication, received support from the Institut Français.

Library of Congress Cataloging-in-Publication Data

Grenier, Roger, 1919– author.
 [Dans le secret d'une photo. English]
 A box of photographs / Roger Grenier ; translated by Alice Kaplan.
 pages cm
 "Originally published as Dans le secret d'une photo, © Éditions Gallimard, Paris, 2010"—title page verso.
 ISBN 978-0-226-30831-9 (cloth : alkaline paper)—ISBN 0-226-30831-6 (cloth : alkaline paper) 1. Grenier, Roger, 1919– 2. Authors, French—20th century—Biography. 3. Photography—History—20th century. I. Kaplan, Alice Yaeger, translator. II. Title.
 PQ2613.R4323Z46 2013
 848'.9023—dc23
 [B] 2012037369

♾ This paper meets the requirements of ANSI/NISO Z39.48-1992 (Permanence of Paper).

A photograph is a secret about a secret.

DIANE ARBUS

CONTENTS

A Box of Photographs

TALKING ABOUT PHOTOGRAPHY is like paying off an old debt. I imagine some cynic saying, "Talk about photography all you like, but spare me the clichés."* I promise to try.

An anecdote to start. I knew an American, Marjorie Ferguson, whose family was straight out of a Henry James novel—very rich people who hired a fellow named George Eastman to tutor their children. One day this Eastman announced that he had invented a new, practical kind of camera, sure to be widely used. He asked them to invest. They refused. Eastman went elsewhere to finance his device, and the name he gave it sounds just like the click of a shutter: Kodak.

The story brings to mind that of the unfortunate young man remembered by the engineer Charles-Louis Chevalier, a famous optician from the early nineteenth century who later introduced Nicéphore Niépce and Louis Daguerre to each other. Chevalier constructed camera obscuras equipped with optical devices that were already quite elaborate. The young man came to see him to

*Translator's note: The pun in the original resists translation: a *cliché* in French can refer both to an overused figure of speech and to a photograph.

find out how much it would cost him to order one. Alas, they were far too expensive for him. It was really too bad, said the young man, because he needed better equipment to perfect his invention. "What kind of invention, exactly?" Chevalier asked. "I've managed to fix images from the camera obscura onto paper," the young man said. Then he placed an image of Paris on the table. Could you call it a photograph? Or a photograph before photography? It occurred to the optician that this young man had found what so many others were looking for. Then the poor wretch left his shop. Chevalier never saw him again.

But doesn't photography really begin with the first child who saw the sky, the trees, the prairies reflected in a drop of water? Or with Aristotle, who, during an eclipse, pierced a tiny hole through a wall of a darkened room so he could observe a slice of the sun cut off by the moon? Fixing the image afterwards was merely a chemical detail.

In 1903, Alfred Jarry published a hilarious, blasphemous article in *Le Canard sauvage*, the satirical newspaper he wrote for with Franc-Nohain and Charles-Louis Philippe. He described the Passion of Christ as a hilly bicycle race. In his tale, Veronica (*vera icon*, the true image) was the first photojournalist.

It would be an endless task to account for all the phenomena that seemed to announce photography, so fervently was it anticipated. Nadar said of the illustrator Constantin Guys, who drew the Crimean War in situ, "He discovered the snapshot before we did."

By 1852, a photographer had appeared as the hero of a novel. He was the young daguerreotypist Holgrave, in Hawthorne's *The House of Seven Gables*.

On August 13, 1850, Delacroix noted in his diary that astronomers in Cambridge had photographed the sun, the moon, and the stars, in particular the star Alpha in the constellation Lyra: "Since the star in the daguerreotype took twenty years to cross the space that separated it from the earth, it follows that the ray of light that fixed itself on the plate had left its celestial sphere

long before Daguerre discovered the procedure by which we've just become the masters of that star."

Writing about the Salon of 1859, Charles Baudelaire cursed a society so vulgar that it was ready for the new invention of photography to replace art: "From that moment onwards, our loathsome society rushed, like Narcissus, to contemplate its trivial image on a metallic plate." And yet Nadar, Charles Neyt, and Etienne Carjat have left for posterity the face of the author of *Flowers of Evil* and, better still, his tormented soul. For once, Baudelaire got it wrong. Photography can be an art.

It is true that people soon started photographing everything and anything: slaughterhouses, dissections, war, babies, loose women. The curiosity of this "artificial eye," as Niépce called it, seemed insatiable. "All, even horror, to enchantment turns," as Baudelaire once said. May he forgive me for quoting him in connection with the invention he so abhorred. Except when he needed it to invent a metaphor. In *Morale du Joujou* [moral of the plaything] he compares the small brain of a child to a camera obscura capable of reducing life's great drama to the size of a toy.

Alongside route 6, near Chalon-sur-Saône, there's a monument commemorating Nicéphore Niépce, a native son. Before the freeway was built I had a friend who never traveled south without stopping his car to take a little nap right in the shadow of that slab of stone.

In my autobiographical novel, *Years in Ambush*, my hero is a photographer. He might have been a pianist in a bar. Two of my fantasies.

Posing for Portraits

EVEN BEFORE THE INVENTION of the Kodak, middle-class people and rich people, beautiful people and ugly ones, were wild about getting their portraits taken to record their family memories. The need had always existed, even thousands of years before the invention of photography. Take that young woman described by Pliny the Elder. When her man went off to war she drew the contours of his shadow on the wall of their room. She kept a faithful image.

Anne Garréta and Jacques Roubaud have written a novel together, *Eros mélancolique*, in which photography plays a central but strange role. As their story unfolds, they ponder: "How did people see faces, expressions, before photography? How did they capture the gesture, the fleeting expression, the furtive movement of desire or defiance that a sudden look, a flash, barely intimated? Could they, in all decency, take the time to scrutinize faces and bodies? Even discreetly? Didn't those pliant expressions elude them? Sleep or death alone fixed them long enough so they could seize them, so they could take possession."

One of the first uses of the new invention was, naturally, the portrait. In the notes on Paris by a fictional Cincinnati business-

man named Graindorge, Hippolyte Taine imagines a vast state
apparatus, almost a ministry, where newly married couples are
required to have their photographs taken. The number and variety
of poses are determined by the wife's dowry. You could also get
your photograph taken—or rather be photographed—on your
deathbed. Victor Hugo, for example, his beard and hair in a halo
of light, photographed by Nadar.

The oldest family photographs in my possession, dating back
to the 1890s, are the only traces of ancestors I never knew. No
one is smiling. Perhaps, for the elderly, it was because they had
lost their teeth. Then again, posing for a portrait was a kind of
ceremony, imbued with solemnity. Still, I'd like them better if
they looked friendlier.

A colored photo of my paternal grandfather is signed "Auguste
Gros, professor of drawing and painting." Auguste Gros took over
the shop of a man named Stéphano at 39 boulevard de Strasbourg.
He was a neighbor. My grandfather operated a printing press at
number 43. I didn't know him. He died during the First World
War, paralyzed from rheumatism, after retiring to his native vil-
lage, Attichy, on the banks of the Aisne—right on the front lines.
He called himself Joseph Grenier but Joseph was his second name.
His first was Barthélemy. Rereading "Angélique" in Gérard de
Nerval's *Les filles du feu*, I discovered that the principal holiday in
certain villages in that region is the festival of Saint Barthélemy.
"It was for that day especially that they founded the great archery
prizes," wrote Nerval. Perhaps the first name of my grandfather,
who was born in 1845, ten years before Nerval's death, came from
that festival. I don't think it had any connection with the Saint
Bartholomew's Day massacre of Protestants.

One can imagine Joseph saw the region with much the same
tenderness as the man whose poignant photograph was taken by
Nadar only three days before his death. What distress in Nerval's
eyes! The picture from January 1855 shows a man who seems close
to us, a friend we would like to console for all the offenses life
has inflicted upon him.

Anyone who owned a store had his picture taken in front of it. The grandfather in front of his printing shop; his neighbor—my godmother—in front of her shoe shop; my father and mother in front of a series of optical shops in Paris, Caen, Pau, Oloron-Sainte-Marie, Tarbes. . . .

Two photos, a portrait and a snapshot, are all I know about my first cousin Fernand Lipman.

My aunt Marthe and her husband posed for Louis, "Photographer of the Porte Saint-Martin." Martha's husband is wearing white gloves, a white bow tie, and a pocket handkerchief, also white. He would die in the First World War, pulverized by a shell.

The photos that came back from the war were not numerous, nor were they very remarkable. A small dog, probably a fox terrier, adopted by the men and named Crapouillot—mortar. When peace came, people scoured the countryside, knocking boldly at farmhouse doors: "Any deaths here?" They would ask for a photograph of the dead soldier and take it away, enlarge it, put it in a fancy frame, then sell it back—a portrait to hang on the wall, forever.

My father emerging from the air gunner's seat in a plane, because he had started in the infantry and ended up an aviator. Later, he can be seen in various veterans' ceremonies, and even under the Arc de Triomphe, in front of the eternal flame. But most of photographs of him show him fly fishing.

When he was drafted into the Austro-Hungarian army during the First World War, André Kertész photographed a group of four soldiers sitting side by side on a latrine set up in the middle of a field. These makeshift toilets were called *feuillées*, from leaves, as in a leafy refuge. . . . They lowered their britches and, as the saying goes, satisfied the call of nature, taking their time. One of those four soldiers was killed in combat. Since he had no other photo of his comrade, Kertész offered this one as a memento to his widow.

How many wedding pictures, how many couples pose on that

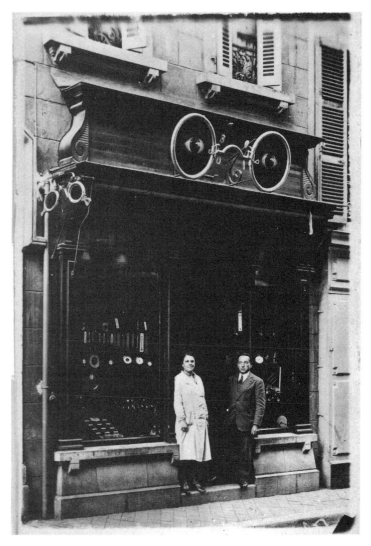

The author's mother and father in front of their optical shop, rue du Maréchal Joffre (Pau, 1925).

fatal day! The photographs have lasted much longer than many unions. Or else they perpetuate the life of the couple beyond death.

Friends of our family, a father, mother, and daughter, were eager to pose before the lens, though these good people were uglier than anyone we knew. They never failed to give us the latest versions of these hideous portraits.

When we talk about photographs collected throughout an entire life, we frequently say that they're stuffed into a shoe box. In our house the shoe box was filled with postcards. Those cards were my travel diaries. I never tired of exploring the box.

Receiving a photograph was considered an honor. For lovers, getting your beloved to give you a photo was the first step along the path to seduction. And when you broke up, it only added insult to injury to return the letters and the photos! Photographing someone was almost like possessing part of them. They say you have to capture someone's expression to take a successful photograph. To take, to capture—these aren't innocent words. Even before the attempt at seduction, getting a girl to let you *take her photo* and keep a copy is like getting a charm or a fetish—something precious. Brassaï showed to what extent Proust was under the spell of photography. He asked people who interested him to give him their photos. If they refused, Proust insisted—he'd go so far as to steal. Apparently his mother and the rest of his family shared this obsession. A photo allows you to dream endlessly—when his charming old friend the Marquise de Brantes sent him her photo, Proust's imagination, assisted by his memory, touched it up, varying the hairstyle and the dress. Proust's passion culminates in *Swann's Way* with the famous scene of voyeurism—the narrator spying through an open window, just as Mademoiselle Vinteuil's girlfriend is about to spit on old Monsieur Vinteuil's photo.

Susan Sontag wrote, "in its simplest form, we have in a photograph surrogate possession of a cherished person or thing, a possession which gives photographs some of the character of unique objects."

Even a man as ugly as the aged Schopenhauer was constantly having photographs taken of himself, which he hung all around him, analyzed, and discussed.

On the other hand, there are people who hate posing for photos. Balzac felt "a vague apprehension" when he was photographed. Henri Michaux had the impression that a part of him was being stolen. They are like Erasme in Hoffmann's tale. Giuletta persuades him to give her his reflection—the image that appears in the mirror: "Leave me at least your reflection, my beloved! I will guard it preciously, it will never leave me." Erasme is surprised: "How could you keep my reflection? It is inseparable from my person. It accompanies me everywhere and comes back to me on every calm and pure body of water, on all the polished surfaces." Then, despairing over their separation, he ends up acquiescing: "If I have to leave, may my reflection stay in your possession forever and for all eternity."

The American photographer Lisette Model locked up her photos at night, so their souls didn't come out to haunt her.

When we keep a lot of photos of the same person at different ages, we end up noticing expressions and gestures that endure from childhood through old age, and that make us say, "that's him, that's absolutely her," as if there might have been some doubt. In Italy, it is customary to announce a death by sending out a little handbill, which always includes a portrait of the deceased, a preliminary version of the photograph that is set into the tombstone. It is posted on walls in the person's neighborhood.

Sometimes we are frustrated by the lack of photos. Why is there only one rather unflattering photo of Flannery O'Connor? For years, there was only a single photo available of Réjean Ducharme, the reclusive and mysterious writer from Quebec. His editors kept retouching it to make him look older, to keep pace with the passage of time.

Baby Box

IN CAEN, RIGHT after the first world war, my father became great friends with a photographer who called himself Gheorge, a drinking buddy, probably the first in a series of bad influences. In return we got portraits on card stock, the typical kind, such as a naked baby—me—posing on a furry white rug.

That was just the beginning. Each of our lives was punctuated by portraits taken in a photographer's studio, either alone, or in a couple, or with the family. We gave copies of these artistic portraits as gifts to close friends and family. Their dignity, their quasi-official character, bore no relation to and in no way interfered with the practice of amateur photography, accessible to all and becoming more and more widespread.

My parents' profession put us in an ambiguous situation. They were opticians, and opticians often added a photo-printing service to their main business. That was the case in the store they owned in Caen. They even gave demonstrations of a new amateur movie camera, the Pathé Baby. The demonstration included a little film, *The Recalcitrant Donkey*, which delighted me (I was two or three years old) and which I recommended to everyone who came into the projection room. The recalcitrant donkey—perhaps a symbol,

my totem. My mother found the clients who had their film developed annoying (she used a more vulgar term). They asked too many questions; they wanted to know why their pictures didn't turn out, were too dark, were too light. They wasted her time. When my parents left Caen to reestablish their business in Pau, they had no desire to include a photo service.

Even so, in their optical shop you could find a stereoscope with its collection of double photos that allowed you to see an image in three dimensions. They used it to treat cross-eyed children. I doubt it was very effective.

As for photography, that was the neighbor's business. A man named Jové, an artist and a bohemian who did a bit of everything, moved into the shop next door. In Pau in those days, no party, no ball, no sporting event, no official ceremony took place without him. He also published brochures and a sort of magazine. He was at once a reporter, an artist, and a shopkeeper. Strangely, we never had much to do with him. And when we needed to have our pictures taken, we went elsewhere.

So, no photo service in our shop, no portraits taken by the neighbor. But we never abandoned our custom of taking one another's pictures on every occasion. We each had a camera. You could say that the formats corresponded to our importance in the family hierarchy. My father had a folding camera, the Kodak 6 ½ × 11; my mother an elegant little 6 × 9 Zeiss. Madam the optician prized the optical products made by Zeiss, the firm from Iena—eyeglass lenses and cameras alike. It was doubtless the only distinction she awarded the people she called "the Boches"—the Krauts. When I turned ten I was given a 2 × 4 ½ Baby Box—a camera so small that I could take photos in class on the sly. The Baby Box thus gave me access to photography, which can be an art, but also a very naïve form of expression. With this little box armed with its lens, I had found an accomplice.

When the Colonial Exposition opened in 1931, my parents sent me to visit cousins in Paris. Their only son, Raymond, a few years older than I, was in charge of taking me to the banks of

Lake Daumesnil, to admire the Temple of Angkor Wat and other marvels. He had a Kodak Vest Pocket. Every time he took a photo, he jotted down in a little notebook the size of the aperture, the time of the exposure, the hour, the weather. I didn't know whether to think of him as admirable or obsessed.

The winter after my return from the Colonial Exposition, my mother decided it would be excellent exercise for me to go skiing on Sundays. The Pyrenees were so near. In the beginning, she put me under the tutelage of an experienced skier who was also a photographer of portraits, marriages, First Communions. . . . The first time we went out, the second-to-last Sunday in November, we took a bus that transported a handful of skiers every weekend—real pioneers—to Gourette. There was the traditional stop in Laruns, at the foot of the mountain. The baker on the town square opened his shop early just for us, and the skiers got their fill of apple pastries to give them strength for the mountain. In Gourette, once we had gotten off the bus, the photographer decided that we would go as far as the Col d'Aubisque, two or three kilometers higher up. I had oak skis made by a carpenter from the village of Nay, whose sons, by the way, were champion skiers. The photographer couldn't afford sealskins, an expensive new product, so he wrapped cords around his skis to help him get up the slope without sliding backwards. When we arrived at the Col, he captured that memorable day in a series of pictures. You can see me in the company of another little boy who had also been put in his care. Apparently my playmate that day became a torturer for the Vichy militia during the Second World War and was executed after the Liberation. At the time, the Pyrenees athletes complained about the photographer's wife, a fat lady who, when she fell, made enormous holes in the snow that were treacherous to the other skiers.

With my Baby Box, I took a photo of the bus, which struggled to take us up into the mountains as the passengers pushed it from behind. It slid on the snowy road, and everyone was afraid it would fall into a ravine. I photographed an even stranger spectacle: the

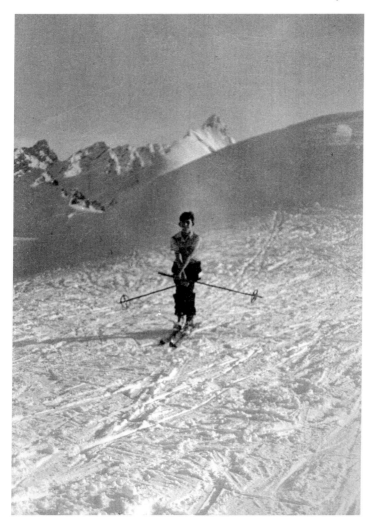

The author learning to ski in Gourette (Pyrénées, 1931).

art teacher from the lycée, his easel planted in the snow, a brush in his right hand, a palette in his left, like a real Sunday painter. I remember him explaining to me that the snow was mauve.

I also took a photo of the peak of Midi d'Ossau, so familiar to the people of the Béarn that they've given it a first name, Jean-

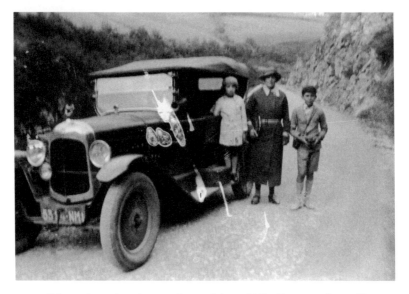

Odette, the author, their mother, and their old B2 Citroën in Sainte-Engrâce (Pyrénées, 1931).

Pierre. It was like taking the portrait of a friend, only he, at least, didn't move, and kept his pose steady.

The Baby Box had a shoulder strap that let me take it with me, proudly, everywhere. As the photographer pictured in a photograph, I can be seen with it at Sainte-Engrâce, deep in the Basque country, and on the road in the Auvergne region, since my mother was wild about the spa treatments at La Bourboule.

I felt as giddy about these first childish photos as would any true shutterbug. Why do tourists take photos of the Eiffel Tower when millions of images already exist? Out of a need to appropriate, to capture the illustrious monument with their very own camera. We shouldn't make fun of travelers who seem to let their camera take their world tour for them. When they push the shutter, they get the feeling that the universe belongs to them.

Photography also changes your relationship with other people

for as long as you have the camera in your hand. "There's a kind of power thing about the camera," Diane Arbus writes, "I mean everyone knows you've got some edge. You're carrying some slight magic which does something to them. It fixes them in a way."

Agfa

AN AD FROM THE AGFA Company caught my attention. If you sent them four five-franc bills, I think (or was it ten-franc bills?), that had serial numbers beginning with an A, a G, an F, and an A, they would send you a 6 × 9 box camera. For this relatively modest price, and for the fun of the game, I became the owner of a 6 × 9 Agfa Box. It took film on wooden spools. Later models used the same size spools in metal. When you bought a roll of film, you had to specify whether you wanted wood or metal spools.

I entered a photo contest sponsored by the children's magazine *Benjamin*, though I didn't win. You had to tell a story through a few photos. In the scenario, I imagined a disobedient little girl (played by a friend of my sister) on her kick scooter, accompanied by her dog (my dear Dick). She ended up knocking over the dog, falling, and bursting into tears. Years later, in another life, I made friends with the man who had created *Benjamin*, Jaboune, alias Jean Nohain, and his brother Claude Dauphin.

As for the old Agfa Box, miraculously, I still have it.

A Summer in the Lab

THOUGH WE NO LONGER had a photo counter in the shop, my father continued to develop his own pictures, printing them and making enlargements. He built a little darkroom in the basement. I was intrigued by the old safelight with multicolored glass that let you choose red, yellow, or blue light.

After seeing my father dunk his proofs in the developing bath, then the hyposulfite, I acquired enough know-how to work in a photo lab for a whole summer vacation. My parents had just sold their business and the son-in-law of the new owner, who managed one of their shops across from the market, immediately opened a photo counter. I don't know why he hired me. Probably so he wouldn't have to pay a real worker. Nor do I have any idea why my parents insisted that I sacrifice my vacation. I suppose so as not to annoy the new owner. Sitting on a stool facing the developing tank, I spent hours repeating the mechanical gestures that resulted in the miraculous appearance of an image. Sometimes, by mistake, we exposed a roll. When the client came to pick up his photos, my boss showed him a completely blackened roll of film—he kept two or three in reserve—and told him that his camera must be to blame. The unfortunate client would then

bring the camera in for repair, which made this not-so-honest businessman laugh a lot.

Another boy worked with me. I happened to know his older sister, whom I used to meet skiing at Gourette. She owned a corset shop. This boy had epilepsy, and once he had a fit while he was holding a valuable camera. He dropped it and rolled on the floor, foaming at the mouth. These fits didn't keep him from telling me how he would spy on his sister's customers when they took off their clothes in the dressing room.

In the evening when I left the lab, I used to give myself a reward—vanilla ice cream from the man who sold out of a cart on the nearby square.

We were now living in a modest house. The safelight with the multicolored glass had been abandoned in the basement of our former residence. At one point I had fun making images with the paper used for printouts. A crude procedure, since all you had to do was place the film against the paper in a little frame and expose it to the sun to get a sepia-colored image. It was the same miracle as in the lab. This photochemistry left me endlessly perplexed. The silver roll of film captured so much more than a chaotic set of dark and light points. It composed an image, and all it took was a few maneuvers to transpose that image onto a sheet of paper. But wasn't it an analogous mystery that the luminous impulses received by the eye and sent who-knew-where in the brain by the optic nerve organized themselves into a coherent picture of the exterior world, and not just any picture? Like a faithful friend, the photograph reproduced the same image as our cerebral cortex did. Photography, etymologically: "to write the light."

Recently a friend sent me a CD-ROM from Russia that had hundreds, I mean hundreds, of pictures of Chekhov and his entourage. Another miracle: How do they all fit on this little disc? For the uninitiated, such are the mysteries of the digital universe. This digital revolution relegates all my little anecdotes to the distant past. And in the end, that's probably why I'm so attached to them. Photographs pour from cell phones, invade

Odette dressed for her First Communion (Pau, 1935).

our screens—they're everywhere. We're entitled to indulge in a little nostalgia.

When my younger sister, Odette, took her First Communion, I grabbed my father's 6 ½ × 11 to take her portrait. This was the folding camera that Pierre McOrlan likened to a silent accordion. A psychologist would call what I did a symbolic act—the son claiming the father's signs of power. Soon I appropriated my mother's little camera, which was more sophisticated than my Agfa Box, and which she hardly used.

In those days a few accessories seemed indispensable: the tripod, the light meter, the various filters, and the little shutter-release cable that separated your hand from the camera and kept it steady. All this equipment lent seriousness to the operation,

both in the eyes of the photographer and of those who saw him at work.

I'll skip over the evolution of technique. Film—orthochromatic, then panchromatic—became more and more sensitive to light, faster. The quality of the paper evolved as well. With my first cameras, nothing forced you to advance the film after you took the photo. If you were absentminded, you'd end up with an amusing collage of superimposed images.

Negative of a Nude

I ENTERED ADOLESCENCE. A number of my friends were also passionate about photography. One of them even had his own darkroom. He let us use it. For some it was a secluded place to take girls and caress a female body, probably for the first time in their lives. As for myself, I received an unexpected request. A friend's mother said, "I hear you know how to develop photos. I have a few negatives I don't want handled by a professional. Could you develop them for me?"

She advised me not to tell anyone, not even her son. "I posed for fun and I've never dared to have them printed."

It wasn't yet the age of the Polaroid, the camera that not only took the picture but immediately spit it out, protecting you from the indiscreet glances of the lab tech.

She handed me a half dozen negatives. When I examined them, I saw a nude woman. Of course, on the negatives, the skin looked black, the hair on her head and her pubic hair white. It was more amusing than the positive image.

Another comrade had a father who was a journalist at *Vu* and lived in Paris, apart from his family. *Vu* was the first magazine that gave pride of place to the image. For that reason it fascinated

me. So did the more frivolous *Voilà*, with its animal photos and articles about models and dancers, not to mention the once-sinful *Paris-Magazine*, whose most truly erotic image may have been an ad for the bookstore De la Lune at 7 rue de la Lune, near the Porte Saint-Denis, that showed a saleslady climbing a ladder and exhibiting her calves. There's a photo by Brassaï showing a passerby in a bowler hat examining the books in the window of that racy bookshop in the middle of the night. And then, in April 1933, providence! *Paris-Magazine* published an article by Fernand Pouey, who later became a friend and thanks to whom I had a career in radio; his article about the painter Juan Seguy was illustrated with photos by Brassaï, another great friend of my future.

Paris-Magazine also published photos by Isaac Kitrosser. I remember his name because much later, after the war, I worked with him a little.

Kitrosser was tall and corpulent. You couldn't forget his body or his strong Ukrainian accent. His many years in Paris did nothing to soften that rolled *r*. We used to tell a lot of anecdotes in which he was the hero. I remember only one of them.

Before the war, one of the most common cars was a Citroën Traction Avant, invariably black. It was hard to tell them apart. So you'd mark yours by painting, for example, two parallel bars on the door. That's what the photographer Kitrosser did. Unfortunately he was not alone in this. One night he left the opera, where he had covered a gala, and went to his car. He saw a man fiddling with the lock on a car door that had two little bars painted on it. He approached without a word and landed a vigorous kick on the butt of the car thief. The man turned around. Kitrosser recognized François Mauriac. The illustrious writer had also painted two little bars on the door of his black Citroën.

All That's Left Is the Smile

MONTHS AND YEARS PASSED. My friends and I continued to accumulate photos. As for the girls who were closest to us, often a photo is all I've kept from our best moments. A smile making two delicious folds at the corner of the lips.... Like the Cheshire cat, all that's left is the smile.

Because of a Leica

THEN THE WAR CAME. While I waited to be drafted, I found work supervising students at the Lycée Montaigne in Bordeaux. I noticed a young math teacher who had a Leica, a camera that was still quite rare. That was all I needed to approach her. She was as passionate about photography as I was. Colette Rothschild (no relation to the wealthy family) was a former student of the École Normale Supérieure, rue d'Ulm, the youngest person in France to have passed the state teacher's exam, the *Agrégation*. As expected, I soon had to leave the Lycée Montaigne for the barracks. Three years went by. In November 1942, I found myself on the sidewalk in Clermont-Ferrand. The Germans had invaded the free zone in the south. The first person I met was the mathematician from Bordeaux. I was about to exclaim, "Colette Rothschild!" but she beat me to it: "I'm Madeleine Verdoux." She was hiding in the Auvergne region. She still had her Leica and we started to talk about photography. She gave me a photo she was proud of that showed the undergrowth of the forest with its subtle play of light. She lived with another science student from the École Normale. She invited me to parties where a group of refugees gathered at her house. She wasn't known to her friends as Colette

The author (*far left*), Marguerite Simon, Paulette Ballini, and (*far right*) Colette Rothschild (Clermont-Ferrand, 1943).

but rather as Mad, short for her fake first name. That was how I made contact with a group of intellectuals who had found asylum in Clermont-Ferrand. They taught me everything, had me read Faulkner and Kafka, brought me into the Resistance. Later, after the Liberation, I was drawn to the newspapers taking shape in Paris and I ended up at *Combat*, Pascal Pia and Albert Camus's paper; I became a journalist, then a writer.* Joseph Conrad has written about "the amazing elections, conjunctions, and associations of events which influence man's pilgrimage on this earth." All of this happened because of a Leica.

*Translator's note: *Combat* was an underground newspaper of the French Resistance movement of the same name. In August 1944, it became a Parisian daily edited by Pascal Pia and Albert Camus. The original team of writers disbanded after Camus left in 1947 and the newspaper was sold. In addition to his daily work on the news desk, Grenier's contributions included theater criticism, coverage of the political trials of the Liberation era, and political reporting on Greece and Spain.

Berthe Utkès (*center*) and companions at a sports camp near Paris (1937).

This was not Colette's only beneficent intervention in my life. We had all gone back up to Paris. In January 1944, while I was living on the rue du Banquier in the Gobelins neighborhood in an apartment belonging to some refugee friends in Tarbes, the Gestapo came and sealed up the door. Fortunately I wasn't

there. My poor friends Berthe and Zelman Utkès—Jewish, Russian, and Communist—had been arrested. Colette and her friend Cassignol, another mathematician, lodged me at their place on the rue du Moulin-Vert, near the Alésia metro stop. They were also providing temporary lodging for another friend from the Clermont-Ferrand group, the philosopher Jean-Toussaint Desanti.

Next I found a hotel, albeit a pathetic one, behind the Place Clichy. But several weeks later I broke a few ribs skiing. Colette and Cassignol welcomed me once again to the rue du Moulin-Vert.

At the time, no one knew that Ernst Leitz, the head of the Leica firm, was working to save Jewish lives. He hired Jews and then sent them, equipped with Leicas, on business trips to the United States. The New York branch took care of them. Ernst Leitz started doing this as soon as the Nazis—the people he called "the brown monkeys"—came to power. But he had to stop his rescue work when war was declared and the borders closed. The explanation for his behavior is very simple: he hated to see people suffer.

Colette died in early 2008, after a very long life. She still had her Leica.

A New Agfa

I DIDN'T BECOME A PHOTOGRAPHER: my professional instrument was a typewriter. Still, photography never stopped influencing the course of my life. Here I need to back up a little. In December 1940, I was still a soldier. I ended up in a regiment in Marseilles and was chosen for duty in Algeria. Until then, my mother's little camera had faithfully registered my tribulations. On one outing, I stopped in my tracks in front of the shop window of a photographer near the Cours Belzunce. I told myself that I couldn't embark on a trip to such an exotic destination, where who knows what adventures awaited me, without a better camera. I emptied my wallet to purchase an Agfa 6 × 9 on sale; it could be transformed into a 6 × 6 by using an interior mask. I started taking pictures of seagulls from our ship, a horrible old tub usually used to transport sheep, which took three days and three nights, most of them in stormy weather, to get us to Algiers by way of the French, Spanish, and Algerian coasts. We mostly stayed in our bunks at the bottom of the putrid hold.

I was barely able to take pictures of a few friends on the bridge during a break in the weather, then a view of the port of Algiers from our temporary camp. And a few other pictures from the

freight car that took us to our final destination, Constantine, where we reconstituted the 3rd Zouave regiment, which was doubtless in need of reinforcements after the fall of France.*

Among the photos from that year in Algeria is a very beautiful one showing a veiled woman crossing under an arch in the Casbah of Algiers; you can see on the wall three large letters, PPA, the abbreviation for Messali Hadj's Algerian People's Party, the first movement for independence, later renamed the MNA, the Algerian National Movement. The catch is that I'm incapable of saying whether I took this picture or whether it was taken by my father, who came to Algeria on business in that same period.

The photos from North Africa immortalize scenes so incongruous that without these paper witnesses I would have forgotten them. For example, a strange machine resembling a steam locomotive in the courtyard of the barracks, which was in fact a sterilizer you dipped your underwear into to kill the lice. A column of exhausted men, dragging themselves along under the sun with their mess kits and their rifles while a sergeant on horseback bursts out laughing. The swamp water that was filtered through a handkerchief, for drinking. One image is enough to sum up the entire year. A mule that has dropped dead during a mid-August march. Within ten days, thirty mules and five men had died that way. When a mule dropped dead, you had to cut off his hoof, which was engraved with his name.

My mania for dragging my camera on all these horrific marches and countermarches reached the ears of the commanding officer, a real horse's ass we called Bébert. He assigned me to photograph parades, which freed me from having to parade myself and sweat alongside my miserable friends.

For an especially important review of the troops, my Agfa was deemed far too ordinary and an officer lent me a Voigtländer. A luxury.

*Translator's note: The writers Roger Grenier, Raymond Queneau, Pascal Pia, and Maurice Nadeau were all Zouaves.

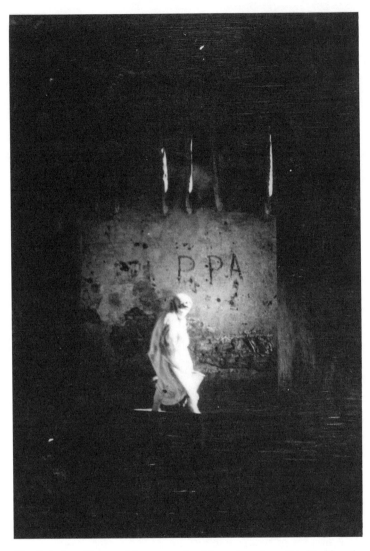

The Casbah in Algiers, with a woman in white and, on the wall behind her, the initials for the Algerian Peoples' Party (Algeria, 1941).

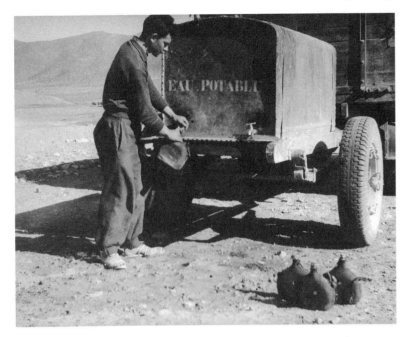

The author, age 22, at N'Gaous district (South Constantine Province, 1941).

I benefited from another unusual privilege. The Corsican ser-
geant, the same one who burst out laughing on his horse while
we died a million deaths on the long Saharan march, was no
better than the other petty officers. But he was so lazy that he
never punished us because he couldn't be bothered to fill out the
report. Once he did file the paperwork to get me a thirty-six-hour
leave; it might even have been a fake leave since he didn't have
the authority. He wanted me to go to Philippeville to photograph
his mistress. Did he know that in antiquity the Romans had
dedicated that Phoenician city to Venus? I doubt it. Nor do I
have any memory of the lady or of the photos I must have taken.
A café terrace in the sun, perhaps.

My role as photographer also got me transferred briefly to
the cinema bureau of the regiment—a cushy assignment. This
consisted of maintaining the movies used for rifle training and

the films which, to our horror, showed the ravages of syphilis—all under the command of a sergeant who was quite good guy, just a little tipsy, like most career soldiers in Africa. At one point I was almost sent to Algiers, to the central film bureau, but that didn't happen. I was teamed up with another draftee, a very nice fellow though terribly absentminded, who got himself into some kind of bind every day. While handling a rifle, he ended up shooting himself in the wrist.

In Constantine, the *Bab el Djebia*, the district for prostitutes, was among the most picturesque. Our Zouave regiment was often in charge of security there, which was not an easy task, since brawls were frequent and we sometimes picked up men who'd had their throats slit with a razor. There was a contrast between the pleasant interior courtyard of the bordellos, their cool shadows, green plants, the murmur of their fountains and, all along the narrow streets, the girls standing in front of the dark little shops, their faces marked by an infinite sorrow. The *chaouias*, the peasants who had come down from the mountains, wandered about, timid and clumsy, incapable of making up their minds. Often a girl would give one of them a push to propel him into her den. I wanted to photograph it all. It wasn't easy, because the men who were hanging around would start to threaten me. Later I showed Brassaï my photographs of the prostitutes' district in Constantine. He liked them so much that he borrowed my negatives to enlarge them, using all of his artistry. Brassaï and I had become very close because he married Gilberte, one of my childhood friends from Pau. It's in part thanks to me that she met him. After the Liberation, she came to Paris so I could find her work, and I got her a job with *Volontés*, the weekly newspaper where I was working. They sent her to pick up some photos from Brassaï. . . .

It may come as a surprise that I say so little about him in a book about photography. It's because I've already written about him for the "Photo Poche" series, and in several exhibit catalogs. He never actually took my picture, except one day when I ran

An Algerian prostitute in the *Bab el Djebia* district, photographed by Roger Grenier (Constantine, 1941).

into him on the boulevard Saint-Marcel as I was returning from the rue Mouffetard with my shopping bags, wearing a hideous scarf around my neck—a fox tail that I had worn as a joke—and he had his Rolleiflex around his. That photo is lost. On the other hand, I photographed him several times, in particular in 1975, in Saint-Joseph Hospital, where he was recovering from a minor

Brassaï in St. Joseph Hospital, photographed by Roger Grenier (Paris, 1975).

heart attack. He had transformed his room with photos on the wall, manuscripts in the drawers, and a typewriter. All that was missing was an improvised lab. In another photo in my possession where Brassaï is the subject rather than the photographer, you can recognize him wearing a kimono on a sofa in an opium den, and he inscribed it for me this way: "My secret portrait from the 1930s."

Backlighting

AT THE CLOSE OF 1941, my stint as a Zouave was over, but my military career was not. For the rest of the winter, I ended up stationed at Mont-Dore with the army ski patrol. From the heat to the cold—such are the whims of the military. Among the skiers, I ran into a lieutenant who loved photography, even if, I'm sorry to say, photography didn't love him. I can still see him standing on the slope. The captain was posing for him, his two poles planted proudly in the snow. Behind the captain, the sun was blazing. Extreme backlighting. Suddenly the captain was overwhelmed with doubt: "Tell me, Lallemand [this French lieutenant had an unfortunate French name that meant "the German," Lallemand], does your camera really work with backlighting?

"With what I paid for it, it certainly should!"

On the Téléphérique

BACK TO CONSTANTINE for a moment. In mid-1941, Pétain's government expelled all Jewish soldiers from the army. In my regiment, one lieutenant went mad, screaming and gesticulating in the courtyard of the barracks. He was subdued with great difficulty and we learned that he'd been put in a straitjacket and committed to a psychiatric hospital. Less than two years later, while I was living in Clermont-Ferrand, I went skiing one Sunday at Mont-Dore. I was on the téléphérique at Sancy with some friends, including Colette, the mathematician with the Leica. And lo and behold, there in our cabin I recognized the unfortunate Jewish lieutenant, now in civilian clothes. I greeted him, introduced my friends. He took a camera out of the pocket of his ski jacket and started to shoot pictures of us. We had the impression he was never going to stop, and we decided there must not be any film in his camera.

A Photo of the Train Station at Tarbes

AFTER I RETURNED TO civilian life, I commuted between Clermont-Ferrand and Tarbes, the home of my mother and sister. Friends from the local Resistance network gave me a photograph. It had been taken in Tarbes just as a train full of STO conscripts was about to leave the station, bound for the German factories that ran on forced labor.* The departing French workers stood at the train windows, yelling and gesticulating. Those old third-class cars, with one door per compartment, were covered with V's for Victory, with the Lorraine Cross—the symbol of the Resistance—and with slogans like "Long Live de Gaulle!" and "Down with Laval!" The entire train was covered in graffiti. German soldiers were patrolling alongside the tracks. They didn't

*Translator's note: As of 1942, young people in France between the ages of twenty and twenty-two were forcibly enrolled in the STO, or *Service du Travail Obligatoire* [compulsory work service]; they numbered 650,000 by the end of the war. Nazi propaganda initially promised the return of one French prisoner of war for every three workers sent to German factories. The threat of the STO motivated many young French people to join the underground Resistance, or *maquis*.

seem to mind much, as if they were thinking, "Let them holler all they want, as long as they go off to work for our war effort."

I can no longer find this precious photo. Have I lost it, or filed it too carefully? From time to time I look for it in my papers. In vain.

The Poor Man's Rollei

I WAS STILL a soldier when my father died. He was living in Oyonnax, where he'd become the sales manager for a manufacturer of eyeglass frames. He was living in a hotel. I went to pick up my inheritance; that is, what I found in his room. First, dozens of razor blades—I couldn't tell whether they were new or used. Why were there so many? I tried them one after another. Enough to last for weeks. Second, a Voigtländer Reflex, which I'm tempted to call the poor man's Rolleiflex.

Among the refugees in Tarbes who became our friends was a couple, Berthe and Zelman Utkès. I've already described how the Gestapo found the Parisian apartment they'd lent me. I think about them every day, and I still can't accept the fate that befell them. Zelman was an engineer at Hispano, and its factories had relocated to Tarbes. But he was also a painter and a sculptor. He tried to find a safe place for his canvases. He also wanted to keep a record of them by having them photographed. I volunteered for the job. Zelman was a meticulous man, never satisfied, barraging you with questions to catch you in some mistake, some sign of incompetence. You couldn't photograph paintings any old way, he maintained. For the entire time the lens was open, you had to

hold a lamp to light the various parts of the canvas just the right way, some parts more than others. It was all about the lighting. I made an appointment one morning. The Utkèses were living in a cottage at one end of town, on the banks of the Adour. He was at the factory and Berthe stayed home to welcome me. I photographed a few landscapes. Then we came to the most important painting, which showed a nude woman, seated, from the back. Obviously Berthe. I took several photos, walking with my lamp to light this undressed body. Next to me was the model, dressed. The woman in the painting had a thick waist, heavy thighs, even heavier buttocks. That was Utkès's style, conforming to Soviet taste. The woman next to me was slimmer. How terribly intimate. . . . I don't remember whether the painter was satisfied with my photos. Soon after, the Gestapo went to their cottage on the banks of the Adour. Soon they sealed up the Paris apartment as well, and all I'd been able to get out in time was a box of photos from their lives before, in Russia, in Cairo, in Paris. The paintings, the large nude of Berthe—what became of them?

A Victim of Heidegger

EARLY IN 1944, CLAUDE, a childhood friend who had been liv-
ing in Bordeaux, came to work in Paris. Adjunct professor at
the Louis-le-Grand Lycée, I think. He proposed a more-than-
surprising encounter: "I met a German soldier in Bordeaux I'd
like you to meet. He's a philosopher who was expelled from the
university by Heidegger and ended up as a second-class infan-
tryman. Because Heidegger is a Nazi and he's Christian, and a
communist."

That was how I learned about Heidegger's political choices
before a lot of other people. I didn't have to worry about my friend,
who was from a left-wing family of freemasons and couldn't be
suspected of the slightest collaborationist tendency. After a quick
lunch in a bistro, the three of us went to the Rodin Museum.
Germans always wanted to visit the Rodin Museum because of
Rilke, who had lived there. Conrad P., tall, with an intelligent
face, was silent and cold. All he said was that as long as the Nazis
were in power, a Catholic such as himself couldn't be a philosophy
professor. He added that Heidegger had expelled his mentor,
Husserl, from the university. As we parted ways at the entry to the
Invalides metro station, he asked me the question that must have

been preoccupying him from the very beginning: "Did you agree to see me because you are an admirer of the German army?"

I responded rather passionately that I had just spent almost three years in the French army and that, as far as I could see, there was nothing more revolting than an army, the German one included.

Then he changed utterly. He became voluble. Showing me the fabric of his uniform, he said, "It's fake. This is how they dress us so we can freeze to death in Russia." Some time later, he gave me his fancy camera to sell, because he needed the money to fund his desertion. (Once again, photography was playing a part in my adventures.) I took the camera to a merchant near the Place de la Madeleine. And Conrad P. finished the war in an underground Resistance group.

At the Liberation, he was taken prisoner, sent to the barracks at Saint-Etienne, and outfitted with a French uniform. Shortly after, he was put back in a German uniform and sent to a prison camp. Thanks to the efforts and testimony of people who had known him in the Resistance, he was released. I remember he stopped in Paris, escorted by the young French soldier who was supposed to be guarding him but who had succumbed to his charm. He had come to appear before I can't remember which office that was supposed to settle his case. It was Christmas. I invited him along with his guard to spend Christmas Eve in my minuscule room in the Gobelins neighborhood.

After the war, I saw him only once, briefly, during one of his visits to Paris. He had become an editor of law books in Düsseldorf. When he learned I was a journalist and that I worked at *France-Soir*, he said, "I have a friend at *France-Soir*, Jean Eskenazi. Send him my best regards."

I was a little surprised. I went to see Eskenazi, who was in charge of sports reporting and who always looked as unathletic as possible—a roly-poly fellow who wore a carnation in his buttonhole.

"I just saw a German, Conrad P. He says you're friends."

"That's absolutely true."

Eskenazi told me a story that I find even stranger than my own.

During the war, he was hiding in Aix-les-Bains, where he'd found work as a bartender. German soldiers used to drink at his bar. One of them in particular caught his attention, because he always seemed so sad. Jean Eskenazi couldn't refrain from asking, "What's wrong?"

The soldier started to lament, "The war . . . Hitler. . . ."

Moved by this, Eskenazi replied, "And what about me, then? I'm Jewish!"

Then he bit his tongue. What was he revealing!

Happily, the soldier was Conrad P. And they became friends.

The Curse of the Voigtländer

IT WOULD BE TOO EASY to blame the Voigtländer, my father's legacy, for everything bad that happened to me once it came into my possession, when in fact I owed those mishaps only to my own idiocy.

To start, skiing on the Sancy, at Mont-Dore, I fell on this camera, which I was wearing around my neck. I thought I might have broken a rib. Returning to Paris after an entire night standing in a crowded train, I was lodged and cared for, as I said, by the mathematician with the Leica and her partner. Feeling worse and worse, I went to consult an old doctor, someone who had courted my mother during the previous war. Probably because he didn't want to worry his old flame, he told me there was nothing wrong with me. Next I consulted a friend who was doing his internship at Bretonneau Hospital. To impress me, he took me to the operating room, where I had to watch him master the art of the appendectomy on one patient after another. I nearly fainted. When he'd finished, he x-rayed me. Yes, two ribs were broken.

Decades later, I fell on a camera again. That was in Saint-Petersburg, getting out of a little boat after an outing on the Neva. I may say more about that when the time comes.

The morning of August 19, 1944, when the popular insurrection broke out in Paris, I looked in vain for my two contacts in the Resistance, Robert Monod from the MLN [*Mouvement de Libération Nationale*] and Pierre Stibbe of the CDLR [*Ceux de la Résistance*]. Monod didn't show up at our meeting and Stibbe wasn't at his appointed spot on Vermenouze Square near the rue Mouffetard. I made a quick tour of the feverish city. There were blue, white, and red flags flying over the Hôtel de Ville, the Palace of Justice, the Cathedral of Notre-Dame. Germans were watching from their cars, astonished. I went home to the Gobelins, a neighborhood not yet caught up in the frenzy, to pick up my Voigtländer. I returned to the Hôtel de Ville, but the crowd had dispersed upon learning that the Germans were firing on people at the Place de la Concorde and on the Boulevards. I took the rue de Rivoli. On the rue des Pyramides, you could hear gunfire coming from the Left Bank. I crossed the Seine at the Pont Royal. German cars were passing by, and there were soldiers crouching on the sideboards, ready to shoot. I can still see the truck with a big guy in it on high alert, waving a grenade. You had to run to get across certain streets. I had my jacket draped over my shoulders with my camera hidden underneath, and I took a few photos. I ended up in the midst of a battle whose epicenter was the boulevard Saint-Germain. (It wasn't on purpose: you were forced to take one street, then another, and in the end, I was stuck.) At the corner of the rue de Bellechasse and the boulevard Saint-Germain, people were ordered to cross the street with their hands in the air. Even though I had reached the back of the National Assembly building, which the Germans were just then evacuating, I wanted to go back and photograph the people with their hands up. So I retraced my steps to the Bellechasse–Saint-Germain intersection. It was calm, no one had their hands up anymore. The boulevard was full of armed soldiers, with machine guns, with tanks. It wasn't good to show the slightest sign of hesitation. Also, and I don't know how this happened, instead of walking down the rue de Bellechasse straight to the Seine, I took the boulevard. This was a problem,

but I was hoping still to get back to the Place de la Concorde. I was stopped immediately by a soldier who saw something under my jacket. While I was being searched, with a machine gun under my nose, I showed some kind of work permit in German that my employer had given me so I wouldn't be taken in a roundup, but this didn't seem to impress them. After some hesitation, they took my camera and let me go. They threw my Voigtländer in the gun turret of a tank. It was a return-to-sender, actually, since this camera is German-made. I tried to protest: "Camera ... valuable...." But a Feldwebel replied in French with a "Get going!"—to which there was nothing to say. Adieu, Voigtländer, legacy of my father! I had to continue along the boulevard, heading toward the Concorde. At every doorstep there were soldiers standing at alert, ready to fire. I'd gone twenty meters when the one who had arrested me cried out and all the soldiers, even the ones on the other side of the boulevard, pointed their weapons at me. I put my hands in the air. A new search. In my jacket pocket was a tricolor rosette with a Lorraine Cross, symbol of the Resistance, which I'd purchased that morning on the Place de l'Hôtel de Ville (the souvenir vendors hadn't wasted any time), but they didn't find it, and I had completely forgotten about it, otherwise I would have been even more nervous. I stood there with the machine gun pressing into my back. The soldier who held it was pushing me. I thought it was to lead me somewhere, so I took a step forward. But that wasn't it. He had me turn so that I was facing the wall of a building. Then I knew with certainty that it was over. I was paying close attention to the situation, but deep down I was thinking that I still hadn't accomplished anything in my life. I said to myself, "already!" and I was furious. Faced with what was about to happen, I didn't see death, but the end of life.

A couple of old people watching the scene from their doorstep started speaking to the soldier in German, a language I didn't understand. A new discussion began; more soldiers were called over from across the boulevard. Suddenly they signaled to me to get going. I didn't really understand that I could. Hesitant at first,

I convinced myself that given where I was, moving was bound to be less risky. The German in charge repeated his signal. I took one step, then another, then proceeded timidly, turning my head around a few times to see if they weren't calling me back.

I wish I could have thanked the old couple, who most certainly saved my life. But I was never sure of the exact spot where they'd been standing. Was it at the corner of the rue de l'Université or the rue de Lille?

With their fluent German, they might have been caretakers at the German Embassy.

Another Woman and a Leica

I LOST MY VOIGTLÄNDER but found my comrades. During the week of the insurrection our group was chosen to liberate the Hôtel de Ville, where we occupied the prefect's office. On the second or third day, a young woman arrived yelling "Where is Léo? Where is Léo?" It was Brigitte Servan-Schreiber, an envoy for Léo Hamon, vice president of the Paris Liberation Committee. She had been arrested by the Germans, but they had let her go after roughing her up. To bear witness, she had herself photographed in the nude, since she too had a Leica, and she showed us the picture of her bruise-covered body.

Now that the insurrection was over, everyone went their separate ways. I met up with Brigitte by accident on the Pont de la Concorde. She was in uniform. She had enlisted in the army. It was the right thing to do, since the Germans hadn't been beaten yet. But my rancor towards the army was so great that I couldn't hide my sorrow in seeing her burdened by what T. E. Lawrence called "death's livery."

There was a strange incompatibility between my two Leica-owning friends. The first one, a Trotskyite, had refused to join us the week of the insurrection. Her principal objection was the

presence in our movement of the second one, whose family, as she saw it, was a symbol of capitalism.

In addition to those two, I briefly knew a third Leica. It belonged to an army buddy who had returned to his family of small-factory owners in Saint-Mandé. He took me boating on Lake Daumesnil and handed me his camera so I could take a picture of him rowing. At the time, it didn't occur to me that we were on the very site of the Colonial Exposition, and that I still had the pictures taken there by my cousin Raymond, who was such a fanatic about photography.

One of the Fine Arts

AFTER THE WAR, the street photographers came back to the city. On the boulevard Saint-Michel, like just about everywhere in the world, they took pictures of the passers-by and handed them a ticket. If you wanted to, you could return later, show your ticket, and pick up your portrait on the front of a postcard. Every time it happened to me, I thought about Panaït Istrati, the Romanian vagabond whose stories I loved for their savage hymns to freedom. He practiced his art in Nice, on the Promenade des Anglais.

I had a new camera. To replace the Voigtländer, I bought an old Rolleicord on sale (actually, my mother bought it when someone came into her shop and offered to sell it). So I remained faithful to the model of the poor man's Rollei. But I'd become a journalist and little did I know that my job would force me to give up photography for years, because of union regulations. Reporters were not allowed to take photos. We used to travel as a team: a reporter, a photographer, and a chauffeur. Thomas De Quincy, a great fan of popular crime stories and author of the celebrated work *On Murder Considered as One of the Fine Arts*, notes that "two imbeciles, one murderer and one murdered," never produced any-

thing of interest. So if you add two other imbeciles, the reporter and the photographer.... But it is true that the demon of art can come and tickle even the crudest photojournalists. For this reason, I am fascinated by the case of Weegee [Arthur Fellig].

Night after night, Weegee, a New Yorker, took the same atrocious photograph. Always a murdered gangster, always a hat on the sidewalk at his side. This stage of his career lasted from 1935 to 1945.

"One good murder a night, with a fire and a hold-up thrown in, kept me in blintzes, knishes, and hot pastrami, with the nice feeling of folding money in my pocket."

Weegee practically lived at the Manhattan Police Headquarters, and when he could afford a car, he was authorized to tune his radio to the police frequency. For him, crime was as reliable as a train schedule. From midnight to 1:00 a.m., peeping toms on the rooftops. From 1:00 a.m. to 2:00, stick-ups of the still-open delicatessens. From 2:00 to 3:00, auto accidents and fires. At 4:00 a.m., fights in the bars at closing time, followed by burglaries and the smashing of store windows. After 5:00 a.m. it was time for the people who'd been up all night agonizing to take a dive out the window. But even a brute like Weegee needed a modicum of staging, and his crude Speed Graphic, with its plates and its flashbulbs, was imbued with artistic aspirations. Before taking a photo of a couple of young murderers in prison, he asked the warden to tell the girl to fix her hair and put on makeup: "The papers like their murderesses pretty and wholesome." About the gangsters struck down on the New York sidewalk that were his daily bread, Weegee confessed, "Sometimes I even used Rembrandt-style lighting, not letting too much blood show."

Rembrandt-style lighting!

Reading Weegee's memoirs, you sense he's not far from thinking that no one has the right to kill, or be killed, without his permission. The shutterbug comes to the conclusion that he is Destiny: "My camera seemed to be deadly as far as the gangsters

were concerned. Once I had photographed them alive I always had to pay a return trip to photograph them when they were finally bumped off. They usually landed in the gutter, face up, in their black suits, shiny patent leather shoes, and pearl gray hats . . . dressed to kill. No bumping off was official until I arrived to take the last photo, and I tried to make their last photo a real work of art."

It would be wrong to think of Weegee as only a crime-scene hack. Crimes were not the only things he photographed. And in any case, he turned out to be a hugely talented photographer. Often he didn't photograph an event, but the people watching it. He reminds us that just like him—perhaps even more so—we are voyeurs.

Weegee's colleague Alfred Eisenstaedt had no fewer than ninety-two covers for *Life Magazine* to his credit. He was born in Germany in 1898 and lived there until 1935. He photographed Marlene Dietrich with Leni Riefenstahl at a ball in Berlin in 1929. This was before the arrival of the Nazis. Also in Berlin, in 1932, he photographed a sixteen-year-old violinist named Yehudi Menuhin. Bruno Walter was with the young prodigy. Soon they were all forced to flee. On June 13, 1934, he was in Venice, where he managed to capture Mussolini shaking hands with Hitler, not yet the Führer, since the elderly Hindenberg was still alive. In September 1933, in a hotel garden in Geneva, Eisenstaedt took the two photographs I find most powerful; the occasion was a session of the League of Nations. Goebbels, sitting on a garden bench, is flashing an enormous smile at someone we can't see. Suddenly, he realizes a photographer is watching, and in the second picture, his face fills with hatred. Eisenstaedt explained in his commentary, "When I have a camera in my hand, I know no fear."

In the 1960s, Eisenstaedt came to Paris, accompanied by an interpreter. Every time he got ready to take a photo, the interpreter would say, "Cartier-Bresson already took that one; Capa took the same shot; Brassaï got that one. . . ."

What French ancestor of Weegee photographed the anarchist Jules Bonnot on a marble slab at the morgue? A fat man with a mustache, wearing a worker's apron and cap, lifts up the famous head to face the lens.*

*Translator's note: Jules Bonnot, an infamous French anarchist whose "Bande à Bonnot" was responsible for numerous hold-ups and murders, died in 1912 from gunshot wounds in a police ambush.

Colors

DURING MY YEARS as a reporter I was always accompanied by a photojournalist, so I made up for what I'd lost by taking an interest in the other aspects of photography. Color, for example. The cinema had taught me a little bit about additive and subtractive procedures, about bichromatic and trichromatic Technicolor, Agfacolor, and even Gasparcolor—I forget what that was.

I always think of Goethe, who wrote that colors are the passions of light.

When daguerreotypes first appeared, people complained that they weren't in color. Several scientists focused on this issue with more or less success: Sir John Herschel, Alexander Edmond Becquerel. . . . There were also curiosities, like photochromes, which were all the rage in Venice at the end of the nineteenth century. You began with a black-and-white photograph and followed the same procedure as for lithographs, using a different stone for each color, and you achieved an absolutely magnificent printed image.

In the 1950s the Lumière labs started to commercialize the autochrome plates they'd invented in 1906. Enigma: Lumière's autochromes were made from potato starch! I used them less

than I would have liked, because my family preferred the classic black-and-white souvenir photo and disapproved of color.

Above all, I dreamed of Charles Cros, author of the immortal poem "Smoked Herring," with its "forever and ever and ever" that danced in our heads. Cros devoted part of his life to researching color photography. At the same time he was studying communication with the planets, not to mention inventing the phonograph. He submitted his procedure to the French Society of Photography, then to the Academy of Sciences and the French Society of Physics. Manet allowed him to use his paintings to perfect the technique. And for proof that Charles Cros wasn't just a wild dreamer, you have only to look at his tricolor print of Manet's *Springtime*.

Forcing

SO I COULDN'T TAKE any more photos. But I could write pages
and pages about the photographers I worked with. Among those
shutterbugs there were pleasant companions and others who were
intolerable—paparazzi—like dogs on the hunt, the ones who had
nothing on their brains but *forcing*. Among their sad exploits I
remember that when Jacqueline Auriol, the daughter-in-law of
the President of the Republic and a test pilot, survived a seri-
ous plane crash, they blocked her ambulance with their car, like
gangsters, and swung open the doors to take their shots. That
was what they called *forcing*. I preferred a grouchy old photog-
rapher whose photos often didn't turn out—he was a Troskyist
to boot. He took me to a shop on the upper floor of a building
on the boulevard de Sebastopol where his comrades were selling
rolls of film at a cut rate. Who would believe that this was the
beginning of the Fnac? *

In some cases, it was impossible to get a photo, but if you were
clever enough, you could convince the family in question to give

*Translator's note: Founded in 1954 as a members-only cooperative, the Fnac
is a French chain that sells books, films, cameras, and computer equipment.

you one of theirs. Inge Morath, a famous member of the Magnum cooperative, once admitted, "I didn't know it was possible to take a photo with a clear conscience."

She developed a taste for photojournalism and recalls the 1950s with nostalgia: "In those days you could feel happy about being a photographer, before it all became an art." Like the gardener sprayed with his own hose in Lumière's silent film, Inge Morath the photojournalist became a victim of the paparazzi when she married Arthur Miller. It was around then that I met her in New York, in December 1967, at that well-known headquarters for intellectual and artistic bohemians, the Chelsea Hotel.

The Jar

IN 1945 THERE was a ceremony at the Czech embassy. The Czechs were returning Robert Desnos's ashes to the French. His widow, Youki, was there, looking rather cheerful. She was joking around with her friends. Paul Eluard leaned against the fireplace and recited a poem by the deceased poet, one verse of which has stayed with me: "Robert Desnos says hello."

It ended with a rush of photographers who fought over the urn, yelling "Hand me that jar!"

Charles Dullin's Bedroom

IN A LONG ARTICLE ON the front page of *Le Figaro*, François
Mauriac took the photojournalists to task for their values. "We've
been assured," he wrote, "that the photographers who found their
way into the bedroom where Charles Dullin lay dying didn't use
their flashes so as not to blind the man whose eyes were about
to close forever.* What honest folk; they'd like us to tip our hats
in homage to so much finesse. Which does nothing to alleviate
the fact that they forced their way into the bedroom of a dying
man." And he called them "kindly vampires."

Today, sixty years after his article appeared, the paparazzi are
no longer kindly in the least. At the time, I wanted to respond
to François Mauriac, to ask those who treated the press with
so much disdain to take the time to study the situation a little
more carefully. Mauriac seemed nonetheless to get to the heart
of the problem: "What appears nowadays to appeal to the public

*Translator's note: Charles Dullin (b. 1885) was an influential actor and di-
rector whose acting workshop inspired Antonin Artaud, Jean-Louis Barrault,
and Marcel Marceau. Dullin died on December 11, 1949, and François Mauriac's
article appeared in *Le Figaro* on December 19, 1949, under the title "Les Pho-
tographes de Dullin" [Dullin's Photographers].

is the idea of capturing human beings in the deepest recesses of their solitude."

But how can we blame our contemporaries for this all-consuming preoccupation, this desire to capture what is still human at the end of life, to find a response to the great question, the anguish of every individual? At a time when moralists and philosophers speak of nothing but humanity, why should we be surprised that what is human has become the centerpiece of our curiosity? And why blame the public and consider this curiosity inappropriate? The torment that pushes the reader to expect newspapers to show how a man suffers, how he dies, how he appears when he finally puts down his arms and his armor, is certainly worthy of the great Christian charity that so appealed to Mauriac. This public searches and suffers, and isn't it better to see it worry, in its own way, about what happens when a person is alone and dying, than to be drawn to more lowly, more frivolous subjects?

People resent reporters and news photographers for having the same goal as the most ambitious novelists, as Mauriac himself. The writer's model is the fallen angel Asmodeus, who lifts the roofs off houses to discover the secrets inside. Asmodeus has become the patron saint of journalists.

True enough, it would have been better to leave Dullin in peace for his final struggle. The great Dullin, who suffered the public's indifference throughout his life, had the right, as death approached, not to fall victim to the sudden curiosity of that same public.

François Mauriac wrote that the photographer pushes his way to the front row in official ceremonies as though he thinks he's invisible. But truly he is invisible, like the undertaker, the secret service agent, and all those other props at our major rituals. And if that bothers some people, it's because they are too high-strung and too easily distracted.

As for God, who plays a big role in Mauriac's article, you might say—though it would be in bad taste—that if He could only be

photographed it would accomplish a great deal and put an end to plenty of questions.

Photojournalists would have no reason to roam the world, and even risk their lives, if they weren't looking everywhere for a single subject—humankind. Of all the mirrors of humanity, photography is the one that tells the fewest lies.

Saint-Germain-des-Prés

AT THE START OF 1949, hoping to escape the loathsome management of the newspaper where I worked, I made a foray into a brand new magazine called *Paris Match*. Jean Prouvost, whom everyone called Boss, just like they had at *Paris-Soir* before the war, asked me to write an investigative piece about the existentialists. He didn't understand all those young people hanging around Saint-Germain-des-Prés; he needed an explanation. So I wrote an article to explain. But when it was published, my great investigative piece was reduced to a few lines and illustrated with a series of photos taken at the Café de Flore by Willy Rizzo and Robert Doisneau. After two weeks at *Paris Match*, I quit.

The Saxophonist

I WAS OCCASIONALLY paired up with a former jazz musician who had traded in his sax for a Speed Graphic, the bulky weapon of photojournalists in those days. His political opinions had evolved with his artistic and professional vocation: from jazzman and freemason to photographer and communist. In October 1946 we went to see Vincent Auriol, then mayor of Muret. I explained the reason for our visit to this leading member of Parliament, the author of the French constitution: "I won't hide the fact that if *Combat* has sent me, it's because we think you'll be the next President of the Republic."

He responded in his southwest accent, "Now don't go around spreading that garbage!"

Vincent Auriol took us in his car from Muret to Toulouse, because we wanted to take a photo of him in the composing room of *La Dépêche*, next to the big marble table, rereading one of the articles he had submitted to the paper. En route, my photographer entered into a pointed political discussion with Auriol, not hesitating to contradict him. Perhaps the future president didn't mind. It was part of his job.

With the same partner, a good guy all things considered, I

went back to Pau, the town of my youth, where the owner of a fancy hotel had been robbed by his beloved valet. Since I couldn't get anything out of the victim, I gave up and went to see my mother, who was living in nearby Tarbes, and I arranged with my photographer that we would meet up on the train to Paris the next morning. When I found him, he was all worked up. While I was away he had managed to get in touch with the hotel owner, so successfully in fact that they had gotten drunk together, had gotten into a car accident, and had ended the night in a bar with the police officers who had intervened at the scene of the accident. One of the policemen was sprawled on the floor with the hotel owner, hugging him tenderly. Out of professional instinct, my colleague aimed his camera right at them. The policeman, using his own no-less-professional reflex, took out his pistol. Too late, because the picture was already safe in the photographer's camera. All I had to do was write the caption: "The police have kept a close watch over Monsieur S. ever since he fell victim to a robbery." I even used the incident in a short story, "Caravan."

In the end, my photographers were pretty typical. Some were never happy with the hotels where we stayed and the restaurants where we ate. Others inflated their expense accounts and spent the proceeds on their mistresses. Sometimes, when I had gone to a lot of trouble earning a witness's trust, my partner piped up at an inopportune moment and the whole investigation collapsed. I remember the time we went to Anjou to investigate some scandal or crime. The whole way down in the car, my photographer kept chanting "Angevin, sac à vin, Angevine, sac à pine"—which translates loosely as "boys from Anjou are sacks of wine, girls from Anjou are sacks of pricks."

In Orléansville, after the earthquake, I felt sick when I saw my partner enjoying a plate of *gambas*, which smelled like the cadavers decomposing under the ruins. To tell the truth, I was more surprised by his appetite than disgusted.

There were also the legends. When King Alexander of Yugoslavia and the French Minister of Foreign Affairs, Louis Barthou,

were assassinated in the Canebière district of Marseille in October 1934, the photographer from *Paris-Soir* supposedly bribed the conductor of the Marseille-Paris Express to slow down under a bridge so that someone could throw a packet of photos of the assassination down to the locomotive. A messenger would be waiting in Paris to pick it up. Those were the days before photos could be wired, not to mention e-mailed. I knew the man in question when he was in charge of the photo service at *France-Soir*, and I wouldn't put it past him.

Destinies

A CHARMING GIRL, neither quite a reporter nor a photographer, liked to say that she had "organized a photo." I don't know what exactly she organized one fine day when an airplane landed at Orly, but she managed to capture the heart of one of the most famous actors in Hollywood, and he married her. People said her family had raised her to be like Colette's heroine, Gigi.

From time to time, I was paired up with a likable photographer, a tomboy named Alicia. A good buddy. But we soon realized that no matter what story we were covering, it always ended with a death. We went to interview the popular old novelist Max du Veuzit, because she had just been decorated with the Legion of Honor. Two days later, we learned that she had died. Unfortunately, my article wasn't just filled with praise, as in a standard obituary. It contained a few catty remarks, not truly nasty—but still. Alicia and I went back on the road to attend the opening of a new university in the Berry region. Just outside Orléans there was a police roadblock, and we found a charred automobile, its four passengers and their dog still inside. We then were sent to the Ardèche, where a family managed to get a new drug to save their little girl, thanks to a community effort. When we got back

to Paris, we learned that the child had just died. We were almost ready to believe in a mysterious curse (which later inspired me to write a short story called "The Exorcism").

A star of silent films named Georges Galli, the lead in *The Man in the Hispano-Suiza*, became a priest at Sanary, in the Var. Two photos, one of him in the film and another taken in his church, are all it takes to understand his fate.

Sometimes a photograph becomes an accomplice to our feelings, a reflection of our subjectivity. When Marie Besnard appeared in criminal court, accused of having poisoned over a dozen people, in photos she looked like a kind of owl or bat. With her head swathed in a black mantilla, her eyes hidden by thick glasses, she was a frightening sight. But her trial ended in farce, thanks to the experts who bungled the evidence: lab samples were mislabeled, one internal organ mistaken for another. When the "good lady of Loudun" was declared innocent, the mantilla disappeared from the photos, the eyeglasses lost their opacity. Like us, what the lens saw now was the face of a good woman, illuminated by a glimmer of joy.

One, Two, Three!

RENÉ SAINT-PAUL, our photographer at *Combat*, was a prince of a man. Uncomplicated, polite, he never made a fuss. Everyone loved him. When Pascal Pia and Albert Camus, the first editorial team, passed the reins to the second, he stayed on, probably because he didn't know where else to go. The paper would soon fall into the hands of the parsimonious Henri Smadja, whom we nicknamed "The Fear of Wages" (as in the Clouzot film *The Wages of Fear*) or just "The Crime," since crime doesn't pay. Because technology had advanced and the era of flammable magnesium had ended, every photographer was equipped with a battery-operated flash. Everyone except René Saint-Paul. At some event where a crowd of journalists was waiting for the arrival of a celebrity, the photographers, who had spread the word about René, counted out loud: "One, two. . . ." On "three" they set off their flashbulbs in unison, so that he could benefit from their light.

One of his photos is often reproduced. It was taken on January 2, 1945. The editorial team of *Combat* had gathered, glasses in hand, to celebrate the New Year.

Later we parted ways because of jobs, political differences, arguments, or maybe just indifference. Pia, Camus, Serge Karsky,

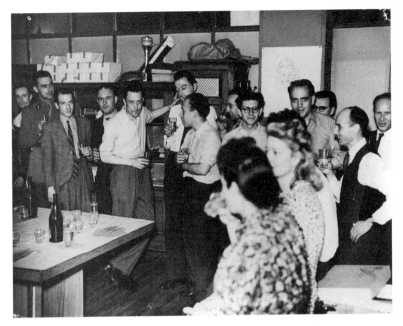

René Saint-Paul's photograph of the editorial team of *Combat* celebrating the New Year (Paris, 1945) (© René Saint-Paul / Rue des Archives).

Henri Calet, Albert Ollivier, Jean Bloch-Michel, Jean Chauveau, François Bruel, Marcelle Rapinat, Charlotte Rault, and also the man who took the photo, left us for another reason, through the absence that is death. The more I look at this photo, the more surprised I am. A team: that's what we were.

The Canon and the Photographer

IN LATE OCTOBER 1946, I was sent to cover the political campaign of the popular Canon Félix Kir, deputy mayor of Dijon. I was flanked by a photographer with whom I'd never traveled before, a discreet young man. For once, my photographer didn't say anything inopportune. He was practically mute. Canon Kir—they named the drink after him, that mix of white wine and crème de cassis—told me that the easiest way to proceed was for us to follow him as he made his rounds that afternoon. He offered to take us in his car.

His rounds that day included stops at the legendary vineyards of Beaune, Meursault, Nuits-Saint-Georges. Since this was Burgundy, the meetings took place in wine cellars, next to the barrels, the casks. At each stop, we were invited to the home of some distinguished local citizen who would uncork another bottle, declaring, "You won't find one of these in Paris for a thousand francs!"

It turned out that my poor photographer was suffering from gonorrhea. He had told me, so I wasn't surprised when he refused each extraordinary glass of wine we were offered. After a few stops, the Canon realized what was going on and it started

to bother him. Finally he took me aside and whispered, "What's wrong with your friend? Is he anti-alcohol or something?"

"No, rest assured. He just has the clap."

"Oh, I see!"

The Canon was reassured. The next morning, before we left, he asked his housekeeper to prepare us an omelet.

Atrocities

IN 1954 I SPENT my winter vacation at Valloire in the company of a photographer from *France-Soir* named Ladevèze. Then I had to leave for Morocco, which was in a state of turmoil over the events preceding its independence. My trip was canceled at the last minute. A driver from the newspaper came to get me at the Invalides airport bus station to tell me I wouldn't be leaving. This happened all the time in those days. Soon after, three men were sent, including Ladevèze. They were caught in an ambush and massacred in the most horrible manner.

It was a century filled with atrocities. In Thrace, during the civil war in Greece, I had obtained photographs of executed prisoners and tortured bodies. On a train to Salonica, in a crowded compartment, those photos fell out of my briefcase onto the wooden benches. My fellow passengers hastened to pick them up for me. The photos seemed to provide some kind of distraction. Among the passengers were soldiers who led me to believe, by their gestures, that they were the ones responsible for what happened. They seemed awfully proud of it.

That civil war in Greece reminded me of photos from the civil war in Spain: soldiers lost in the mountains, trucks ascending in

the night, in the rain. The pictures were interchangeable and I started to believe that all civil wars looked alike.

I knew journalists, reporters, and photographers who loved war, and besides, that was all they knew. They were mad about war. During World War II, a woman named Lee Miller became a famous war correspondent. A *Vogue* cover girl (she created a scandal when a photo of her by Steichen appeared in an ad for sanitary napkins), she arrived in Paris, where she met Man Ray. She became his model, his student, and accidently invented the technique for solarized photos that her lover would perfect. She starred in Cocteau's film *The Blood of a Poet*. Then she became a war correspondent, and when Paris was liberated, Picasso said to her, "You're the first Allied soldier I've seen!" In Munich, she discovered what had been Hitler's house and took a hot bath in the Führer's tub. More seriously, the day after the liberation of Dachau, she entered the camp and her photos bear witness to the horror. She also photographed one of the guards, a torturer who hanged himself from a radiator. They threw his fat, well-nourished corpse onto a pile of the skeletal cadavers of his victims. A little later, in Hungary in 1946, she was there with her camera when the former Prime Minister László Bárdossy was executed. Should I admit that what moves me most of all are the stereoscopic photos her father took of her in the nude, under the pretext of scientific research—one wonders what kind—when she was still an adolescent? And her son, Anthony Penrose, published them. Strange Lee Miller, who liked to say that no one had ever truly loved her.

One day, in the region around Limoges, I was invited to visit the abandoned house of a recently deceased writer, and imagine my surprise to find large photographs scattered on a table! I took a closer look. They were signed portraits by Izis, the Jewish-Lithuanian photographer and member of the French Resistance. Portraits of Resistance fighters, members of Georges Guingouin's fierce *maquis*.*

*Translator's note: Guingouin was the leader of the *maquis* in the Limoges region.

The Beach at Ostia

HOW CAN YOU NOT COMPARE the photo of Chekhov at Yalta with his two little dogs, Touzik and Châtaigne, to Cartier-Bresson's photo of Faulkner, also with his two little dogs? Sometimes you find yourself in a setting, a landscape, even with a person, that gives you a sense of déjà vu. Proust in Venice, slumping on a balcony at the Lido beach, in 1900, brings to mind both *Death in Venice* and Charlie Chaplin as the tramp—the way he looks in *The Immigrant*, in 1917.

I had an analogous impression in 1954, during the Montesi Affair, a scandal that rocked Italy. The body of a simple country girl named Wilma Montesi was discovered on the beach in Ostia. It was not a murder—she had died during an orgy, in a villa. Celebrities from politics and film were involved. Along the beach, just where the poor girl's body had been found, I searched with a photographer for the best angle, the best frame. I later recognized that exact vision of a deserted beach in a scene from Fellini's *La Dolce Vita*. The same beach, the same white light, the same desolation.

I can't help but add, even though it doesn't have much to do with photography, that among some eighty-four protagonists of

the Montesi Affair, one of the prime suspects was Piero Piccioni, the famous composer of film scores and son of a cabinet minister in the Christian Democratic Party. Alida Valli, the sublime star of *Senso*, provided his alibi: "Piero is my lover, and we were in Amalfi the night of the crime." Which was probably false. Then she disappeared, to escape the reporters.

During that same period, I happened to be working as a ghost-writer for a famous plastic surgeon in Paris. He was very conscientious, and he insisted that I attend his operations. One afternoon when I was in his clinic in Neuilly, watching him straighten a nose or remove the pockets under someone's eyes, the door of the operating room swung open. And Alida Valli appeared, smiling, wearing a bathrobe. She wasn't there for an operation. She was hiding in her surgeon friend's clinic.

To get back to photos, the plastic surgeon used them quite a lot. He took pictures of his clients' profiles, explaining what wasn't right and then rectifying the image with a thick wax crayon, until both parties came to an agreement.

An Angel of the Streets

AT THE REQUEST of Pierre Lazareff, the publisher of *France-Soir*, I worked with a murderess who had just spent six years in prison. I wrote some articles about her, helped her write her memoirs, and even drafted a film script based on her life—though it was never produced. Sylvie Paul would have been an ordinary criminal had she not had steel-gray eyes whose tragic look captured the reader, even in the poorest-quality photos that appeared in the press. Because of those eyes, those photos, the sordid crime at the hotel in the rue Neuve-du-Théâtre (during a drunken brawl, she had killed the hotel owner, her lover Jeanne Péron, by smashing a wine bottle over her skull, then buried her corpse in the walls of the basement) became a celebrated criminal court case. Because of that look of hers, Sylvie Paul—born in poverty, converted to rebellion in a children's reformatory, thrown into war, concentration camps, Berlin in ruins—fascinated everyone who came into contact with her. Because of that look of hers, Sylvie Paul inspired a novel by Jean-Louis Bory, *Fragile ou le panier d'oeufs* [Fragile, or the basket of eggs], even before she committed her crime.

When she was released from prison, Pierre Lazareff, also under the spell of those steel-gray eyes pictured in his newspaper, asked

me to contact her to purchase the rights to her memoirs, and, if need be, to write them. That was in 1962.

After an exchange of letters, she arranged to meet me at Sète. Early one spring afternoon, I went to the address she had given me. It was a Protestant church! The church was closed, and the concierge couldn't give me any information. No one was there except some boys and girls from the parish youth group, playing in an annex. I took a seat on the only bench in the courtyard and warmed myself in the sun as I waited, harnessing my journalist's patience. At last her emissary arrived. With an air of mystery, he asked me to wait. After another hour, a car dropped off a nondescript little woman. That was Sylvie Paul. She was afraid of being recognized and had taken all sorts of precautions. I would never have recognized her: dressed in gray from head to toe, wearing flat shoes and carrying an old leather briefcase.

There was something strange about the way she was dressed. It took me a minute to figure it out. It was the way people had dressed a decade earlier. She was wearing the clothes she must have deposited with the warden when she entered prison: a blue-gray suit with square shoulders, cinched at the waist.

We went to a café and sat in the back. She started to talk. She opened her briefcase, which was stuffed with notebooks, old letters, photos, administrative and legal paperwork, lists of deportees (she herself had been deported, though it was never clear whether this was for acts of resistance or because she had robbed a Wehrmacht officer after turning a trick). Was any of this proof of anything? There was a sea of paper, incomprehensible to anyone who didn't know every detail of her story.

Sylvie Paul talked. She talked and smoked without so much as touching her cup of coffee. She spoke for three hours before I ever got around to telling her what we wanted and why I'd come to see her.

During those three hours she talked about her children, the torture she'd endured when they were taken from her. And then, without my having asked—I still hadn't gotten a word in edgewise—she

started to talk about the death of Jeanne Péron. Slowly, without a single detail missing, the nightmare unfolded in a way I don't know how to describe: a crime, an act of anger, an accident. Everything came into focus as though her memory were a film in slow motion: the blow to the head, Jeanne Péron's fall, her fear, the comings and goings to and from the room where the corpse lay, the wait for an impossible resurrection. And then the basement and the sarcophagus where she walled off the dead body.

Her slow monotone, neutral, unflagging, gave her story an intense necessity, as if the very thread of destiny were unfolding. Our coffee had been cold for a long time and we were out of cigarettes.

This first meeting made me think that the best way to collect Sylvie Paul's memories was to have her speak into a tape recorder. We made an agreement and she came to Paris. Besides, the Protestants in Sète who had sheltered her after she left prison couldn't keep her indefinitely.

We recorded for days and days. As we went along, I discovered who she was. Not for a second could you believe she was a bad person. On the contrary, I discovered in her a slightly frenzied need for altruism, devotion, and faith that had catapulted her into most of her misadventures. She had a vitality that even the years in prisons and the camps hadn't destroyed. And an often naïve propensity for imaginative flights of fancy. A little more discernment, better direction to start with, and her life would not have been ruined. But her story was exemplary precisely because it showed that however many good qualities you possess, there's no hope for you if your environment is bad. Sylvie Paul's destiny was forged once and for all in her childhood, when her mother beat her and sent her out to steal, and in the so-called institutions of reform.

One of her lawyers sought out a good Samaritan to lodge her in Paris. That was how a couple living near the Nation metro station, Jean-Jacques Rousset and his companion, came to offer her their hospitality. I went to their apartment several days a

week, carrying a heavy old tape recorder, to gather the calamitous history of her life.

I realized very quickly that this was far from an ideal refuge. The war in Algeria was raging and Jean-Jacques Rousset had joined the FLN underground—the revolutionary Algerian freedom party. The OAS, the French secret army, was looking for him in order to kill him. Besides which, he had ordered the murder of members of the MNA, Messali Hadj's party and enemies of the FLN, and the MNA also wanted him dead. It turned out that he had run off with the wife of the head of the French federation of the FLN, so the FLN was after him too. One footstep in the hallway and he trembled. If the doorbell rang he hid behind the bed. He pointed at his forehead and said, "I only have one head—I don't want any lead in it."

That was the atmosphere in which Sylvie Paul and I were recording her memories. I kept urging her to find a less dangerous refuge. Finally she found work in a bottle factory and a place to live in Issy-les-Moulineaux. I didn't dare point out that clearly bottles were still playing a role in her life. From then on she came to my place for the recordings. We made coffee as the tape rolled.

A few days later there was an assassination attempt on Charles de Gaulle at the Petit-Clamart. At our next rendezvous, Sylvie Paul said, "You know the attempt on de Gaulle's life? Those are the people I work for in Issy-les-Moulineaux!"

Knowing her mythomania, I didn't think I needed to pay much attention to her story.

As for Jean-Jacques Rousset, he survived the Algerian war without a scratch, but death caught up with him in the form of a devastating throat cancer.

As she spoke into the microphone, I watched Sylvie Paul revisit her life and maybe even discover the reasons for her misery. Sometimes she was stopped by her tears. She forgot the microphone and the tape recorder, the machine with its little light. She spoke only for herself. When the tape ran out, she kept talking. We

ended up with twenty hours of tape recordings. The transcription of the tapes came to six hundred typed pages.

Her memoirs were published in a newspaper, then in a book. As for her account of the murder on the rue Neuve-du-Théâtre, it's totally incoherent since we had to make cuts. Sylvie Paul blamed everything on one of her lovers at the time, an Algerian who was tried along with her but acquitted. Then came the war in Algeria, the years spent in prison. We thought that if he was alive, the Algerian would certainly have disappeared. Not at all. He was still living in the same room, in the same hotel where the owner had been killed and her body entombed in the basement walls. As soon as the first article appeared, he sent his lawyer to see us. So we had to cut anything concerning him.

But I haven't finished with Sylvie Paul. She came back to see me at the newspaper, to announce that she was having a rough time and was going to enter a convent. She had always had religious tendencies and had leaned sometimes toward Protestantism, sometimes toward Catholicism. I suspected that this was related to the charitable potential of one or the other church. This time she wanted to take the veil. In a convent near Besançon called Béthanie—the convent in Robert Bresson's film *Angels of the Streets*. Béthanie specialized in mixing girls from the best families with repentant sinners, ex-prisoners, former prostitutes. In theory, you weren't supposed to know who was who . . . in theory. She wanted to sell my newspaper the story of her entry into the order, because she needed money for her children. Indeed, throughout her tribulations, her years on the run, she was always pregnant and dragging some child around with her. The children who had been taken from her were entrusted to her brother. Thus I accompanied her to Béthanie with a chauffeur and a photographer. We stopped for a last lunch in Besançon. She was crying a little.

Then it came time for her to enter the convent. She asked us to stay at a distance as she walked toward the door. The photographer kept shooting, using a telephoto lens. He took one shot of her ringing the bell at the convent door, another of the

door opening, another of the door closing behind her. He was satisfied.

I should add that Sylvie Paul didn't stay long at Béthanie, the convent in *Angels of the Streets*. She left. With no photographer in sight. But who can forget the look on her face in those newspaper photos?

News Photos

AT THIS POINT, as I ran around in search of stories with my photographer friends, I sometimes ended up appearing in photos myself: during the autumn literary prizes, in the background of a picture of the actress Madame Simone or the Duchesse de la Rochefoucauld; in Bourguiba's palace in Carthage. During the 1956 Winter Olympics, Sophia Loren is seated at a banquet table in Cortina d'Ampezzo and I'm standing behind her. In my white shirt and black bow tie, I look like one of the flunkies bringing out the dishes. At the other end of the Italian boot, I can be seen with Melina Mercouri on a beach at Pouilles—I was on assignment for *Elle Magazine*, covering the making of *The Law*, Jules Dassin's movie based on the Roger Vailland novel. In addition to Melina, the cast included Gina Lollobrigida, Marcello Mastroianni, Yves Montand, and Paolo Stoppa. The magazine assigned to me a young photographer who became the great Jeanloup Sieff, an artist who could photograph women better than anyone. After a day of filming, we all went down to the beach and lay around in our bathing suits, joking with one another.

In another genre, you can see me at the Palais de Justice in

The author with Sophia Loren during the Olympic Games (Cortina d'Ampezzo, January, 1956).

Paris in 1945, standing next to Pierre Laval and Joseph Darnand as they were about to be tried for treason—and what a strange sensation it was to stand alongside these two living dead men, since it was already clear that their fates were sealed.

Gisèle's Grudge

I RAN INTO GISÈLE FREUND at the Hôtel de Lassay during a ceremony in memory of Colette Audry. And this is what Gisèle Freund said: "Thirty years ago I took your photograph. And you never asked me for the photo. You have nothing but disdain for my work. . . ."

I replied that on the contrary, I was so young and intimidated by her in those days that I wouldn't have dared to make such a request. But what a memory!

After that explanation, she sent me the photo in question. One of my hands is resting affectionately on my typewriter. And I decided that my hair looked too short.

Police Interference

WHEN I SAW WHERE BRASSAÏ developed my photos of the bordellos of Constantine, I was hugely surprised. The world-famous photographer used his bathroom as a darkroom. One of the little-known episodes of his life took place in that tiny room. His apartment building was located at one end of the rue du Faubourg-Saint-Jacques. At dawn on August 25, 1944, from that same bathroom window, he watched the soldiers of the Leclerc Division in action, running down the boulevard. He started to photograph them. Suddenly, gunshots were fired at his window. They probably came from soldiers who thought he was a sniper. One of the bullets shattered the glass above his head. Brassaï never had the damage to the walls repaired, as a memento.

In his two rooms on the rue du Faubourg-Saint-Jacques, he squirreled away his archives, his books, and the kind of bric-a-brac that appealed to the surrealist generation. A pebble, the wishbone from a chicken or a rabbit, anything with a strange shape found a spot on his shelves.

In those days, photographers didn't make a living wage. It wasn't until a few years before Brassaï's death that the price of collectible photos started rising astronomically.

Around him was a small group of photographers, most of them Hungarians like him. I remember Ergy Landau, a woman with lots of humor and malice. And then one day the police made a raid on those impecunious artists. Search warrants, rude words, threats: "You might as well kiss your naturalization papers goodbye!" Whenever they could, the victims of those searches phoned their colleagues and had them hide their illegal photos. They took pornographic pictures to make ends meet. They were careful not to sell them in France but had them smuggled into foreign countries. The Dutch had just filed a formal complaint, which is why the French were obligated to take action. Those poor photographers were in a bind, and I spoke to Pierre Lazareff, who called the Minister of the Interior. The whole affair was settled quietly.

These episodes of bohemian life inspired an episode in Henry Miller's *Tropic of Cancer*. He alludes to keeping company with a photographer whose name he never mentions. What other photographer could it be but the man he called "the Eye of Paris," the man who later wrote *Henry Miller, the Paris years* and *Henry Miller, Happy Rock?* From the time I first knew him, Brassaï would give me little photos, simple contact sheets showing Miller and Anaïs Nin at the Villa Seurat, just to satisfy my curiosity. In one of them, Anaïs is dressed up as a Spanish dancer.

"Then one day," Miller wrote in *Tropic*, "I fell in with a photographer; he was making a collection of all the slimy joints of Paris for some degenerate in Munich. He wanted to know if I would pose for him with my pants down, and in other ways. I thought of those skinny little runts, who look like bellhops or messenger boys, that one sees on pornographic postcards in little bookshop windows occasionally, the mysterious phantoms who inhabit the rue de la Lune and other malodorous quarters of the city. I didn't like very much the idea of advertising my physiog in the company of these elite. But since I was assured that the photographs were for a strictly private collection, and since it was destined for Munich, I gave my consent. . . ."

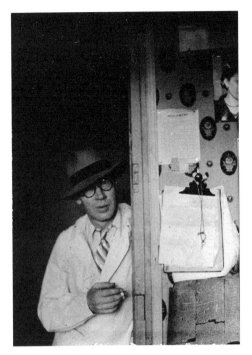

Brassaï's photo *Henry Miller* (Villa Seurat, Paris, ca. 1930). © Estate Brassaï– RMN-Grand Palais/ Michèle Benoit. Private collection.

Henry Miller concludes, "When you're not in your home town you permit yourself little liberties, particularly for such a worthy motive as earning your daily bread."

I've already written quite a bit about Brassaï and I wouldn't want to repeat myself. I'll just add that I saw him draw, paint, sculpt, make a film, write, collect stamps, organize the history of the world into synchronic tableaux. I never saw him take a photo. Except that one time I mentioned, on the boulevard Saint-Marcel.

One of the most original ways Brassaï had of bridging the arts is his book *Paroles en l'air* [words in the air]. By transcribing without any commentary what his housekeeper Marie or what a taxi driver said, he replaced the eye with the ear.

In his *Conversations with Picasso*, he proceeded the same way, tuning in to Picasso's wavelength.

To Each His Photographer

I WAS CLOSE TO BRASSAÏ, while my friend Claude Roy was close to Cartier-Bresson. André Pieyre de Mandiargues was too (except the time they argued because Cartier-Bresson found Venice atrocious). For Daniel Pennac, it was Doisneau. Marc Bernard had Izis. But the photographers didn't get along with one another. We never could have brought them together.

Claude Roy, probably exaggerating my passion somewhat, always gave me a book on the history of photography or a monograph on some great artist of the lens as a New Year's present. Until there was no more room on my shelves.

In 1952, with the American Paul Strand, Claude Roy wrote the text for a photography book called *La France de Profil*, a portrait of a rural life that still existed. There was just enough time. The photographer caught the fleeting images of a world already half destroyed. And the writer gathered the nursery rhymes, the songs, the forgotten stories, erased from our memories today.

Claude also wrote the commentary for a collection of cruel images taken by Michel Vanden Eeckhoudt in several zoos throughout the world, an uncompromising portrait of animal servitude. In his text, he alludes to a particular day I spent at the Vincennes

Zoo when I was a journalist: "One of my friends had the experience of sitting in the back of a cage at the zoo for several hours. He returned exhausted and practically terrorized: the cries, the gestures, the banter of the spectators struck him like the vision of a nightmare."

An Official Image

EVERY YEAR AT THE LYCÉE, we sat for a class photo in the courtyard: two rows, with a teacher reigning in the middle. I can't find any of them. I seem to remember that what amused me most was the way the name of the photographer's firm—Tourte et Petitin—rolled off the tongue.

In France, as soon as anyone starts to enjoy a bit of notoriety, if only because they've published a few books, Harcourt Studio asks them to pose for a portrait. Rendezvous in the Champs-Elysées neighborhood. Carefully combed, not a hair out of place, a bit of makeup, a falsely natural pose, the obligatory smile; careful lighting, a softened image retouched with an airbrush; in other words, the very opposite of any idea I have about myself from dozens of snapshots that record a life in which I have taken many photos and loved photography.

As for Harcourt Studio, I have to quote the diary of Philippe Jullian, who likened it to a movie palace and a whorehouse: "The studio sends invitations to everyone. Its headquarters is a sumptuous hall on the avenue d'Iéna, with tons of marble and gold. Beautiful photos hang from heavily sculpted wood paneling, each a little mysterious. They make you wait in a hall of mirrors, then

you're led along vast corridors to a small room where you wait a little longer before entering the dark photo studio, and there you can make out lamps and reflectors, a piano in the corner, a stool in the middle. Suddenly you are blinded by reflectors and photographed."

The studio gave me a copy of my portrait. I was ready to destroy this masterpiece but my mother was delighted to see her son pictured at last in a quasi-official manner. I was happy to give it to her. The only downside was that I saw it in her living room whenever I came to visit.

I wonder what it's like for photographers to take portraits of writers day after day. I've known a few of them, extremely likeable people. I'm thinking of Jacques Robert, Jacques Sassier, Catherine Hélié, Louis Monier. . . . One of them, whose job for years was to work with writers, confessed to me one day, "I've had enough of photographing writers. I'm stopping."

"But what are you going to do?"

"I'm going to photograph painters."

A Source

AFTER I LEFT the world of journalism, I started to walk around with a camera, like everyone else. Once you make it your business to be a writer, photos—whether you've taken them yourself or not—become much more than memories or documentation. They are trampolines for the imagination, a source of inspiration I could not do without. Writing becomes like those curious infrared photos where, thanks to the body heat that's been left behind, the film manages to record the image of someone who hasn't been there for an hour, who is already swallowed up by the past.

In any case, every photo, even the most insignificant, fixes a moment in time. Who knows where our imagination, our obsessions, will lead us when we see it? Izis set himself up in a garret to get an evocative shot of the rooftops of Paris. He was struck by the way two woolen stockings were hanging from the window opposite his. His friend Marc Bernard, asked to comment on this photo, flashed on a memory from 1943. What it brought to mind were the legs of a man who'd been hanged: "At the gates of Nîmes, the bus stopped. On the arc of a bridge, a man was hanging: a man fell, then began to catch his balance. Six others

were thrown into the void. Around them, the arches were blue; below green men kept guard."

I will never forget the day I saw Jacqueline Picasso in a gallery at Cannes, beside herself when she saw the famous photograph by Brassaï of the painter in the prime of life. After a long moment she murmured, "What a beautiful man he was!"

One summer in Lucca, Tuscany, during an antique fair, I noticed a photo signed by the Alinari brothers, Florentine photographers. It was a portrait of a young woman from another era, a young girl that is. I could not take my eyes off it. I wanted to buy it, but I kept walking. Ever since I've dreamed often of this photo, doubtless more than if it were in my possession.

Such a portrait seems to be the fruit of a minor miracle. A moment of grace preserved. A second later, it would have been lost, with no recourse. This is what Willy Ronis has called "the perfect moment." He adds, "I know if I wait, I'll miss it. I love the precision of that moment."

Who isn't fascinated by the picture of Alice Liddell as the "beggar maid," without a doubt the most beautiful of all the portraits of little girls taken by the Reverend Charles Dodgson, alias Lewis Carroll? Insolent, provocative, her head bowed forward, her shoulder bare, she looks you straight in the eye. This very famous photo was created around 1859. Alas! Julia Margaret Cameron, a British eccentric, great-aunt to Virginia Woolf, developed a passion for photography. And in 1872 she took a series of portraits of Alice: as Saint Agnes; as Pomona; as Aletia, which in Greece means the vagabond, the beggar (an allusion to Lewis Carroll's photo); and even as Cordelia, King Lear's daughter. Ten years, perhaps twelve, were all it took for the little girl to go to seed, for her features to coarsen, for her mouth to turn downwards, for her piercing glance to dull. Where did little Alice go? To thank her nonetheless for what she had been, Columbia University gave her an honorary degree in 1932 in celebration of Lewis Carroll's centenary. She lived another two years.

You won't believe me, but a long time ago I visited the last little girl photographed by Lewis Carroll. For that 1877 portrait, he dressed up Ethel Hatch as a Turk. The actor Jacques Brunius, a member of Prévert and Renoir's crowd who stayed in London after spending the war in exile, drove me to her house. We know that Mr. Dodgson pretended to like all children, except for little boys. Ethel Hatch showed me a letter in which he told her to "come alone, because I like little girls better one by one than two by two or four by four."

Lewis Carroll is not the only writer who succumbed to the demon of photography. When the fashion for daguerreotypes hit the United States, Edgar Allan Poe gave his compatriots a pronunciation lesson: "This word is properly spelt Daguerreotype, and pronounced as if written Dagairraioteep. The inventor's name is Daguerre, but the French usage requires an accent on the second e, in the formation of the compound term."

Emerson made fun of the heroic effort required to pose absolutely still, without batting an eye—and with what result? Looking like a mask.

In 1843, Gérard de Nerval wanted to immortalize the magic of Egypt. In the desert, his chemicals got dangerously overheated. His daguerreotypes were utter failures. In a letter to his father, he complains that the science of the daguerreotype was constantly progressing, not that it did him any good. In the land of the Pharaoh, Gustave Flaubert assisted his friend Maxime Du Camp, an accomplished photographer. His images of the Orient became the first photography book published in France. Gustave cleaned the cuvettes and noted that his fingers were turning black from the silver nitrate.

The champion was Émile Zola. He owned six cameras, set up six different labs for developing photos. He closed himself off in his labs until his wife began to fear for his health. He kept up to date on every new product, every type of paper. He said that photography was to him what the violin had been for the painter Ingres. And that he was a "martyr to photography." Did taking

pictures inspire him to write, or merely provide documentation? Certainly his taste was consistent. When he started, he took photos of locomotives, the Paris-Le Havre Express and also the Saint-Lazare station. But it had been five years since he'd written his railroad novel, *The Human Beast*. Among the thousands of views, scenes, landscapes, portraits that he's left us, I have two favorites. In the first, children are fighting over a game of croquet, exactly as I remember doing in my own childhood—scenes I used in my novel *Le Palais d'hiver* [the winter palace]. In the second, in Médan, his horse Bonhomme turns his head to look at the lens. He's being held by a tiny mustachioed man wearing a straw hat pushed down nearly over his eyes, so that the whole scene looks straight out of a film by Mack Sennett.

And what about intellectual affinities? Zola took a few pictures of the famous moving sidewalk at the 1900 World's Fair, the one that inspired Courteline to write *Article 330* about the trial of a man named La Brige who was so annoyed by the moving sidewalk beneath his window that he flashed his behind at 13,697 passersby.

Frederick Rolfe, alias Baron Corvo, claimed to have invented new techniques in underwater photography. But, probably because this impossible man was always fighting with his benefactors, they didn't amount to anything.

Frederic Prokosch, an American writer whose novels I love (*The Asiatics, The Seven Who Fled*), decided one day never to write again. He started taking photographs of people, another way to create portraits. You find the same idea in Chekhov's short story "Three Years." One of the characters, Kostia Ivanovitch Kotchevoi, discouraged because editors were always refusing his manuscripts, decided to move on to photography. "Photography is an art, too, like writing," he claims with conviction.

I could also cite the reverse—a certain number of photographers who also were writers.

As for painters, they have found in photography a new tool for their work. Delacroix used a technique that helped him with his

drawings, then his paintings. He made daguerreotypes of nude models and copied from them. Actually he chose the models and posed them, but it was his friend Eugène Durieu who took the daguerreotypes for him. Delacroix then brought the daguerreotypes to the country for his work. No need to move the models. The poor men and women he used were not good-looking. They even seem grotesque to us today. Whereas his drawings are admirable.

Courbet and Millet also used photography to prepare their drawings. Corot went further, with the *cliché-verre*. He took a negative on glass and, with the aid of a stylus, drew what he wanted on the emulsion—a portrait, for example. Corot engraved at least sixty-six of these. Delacroix, Rousseau, and Millet also tried their hand at photography. Later, even Picasso had fun in his studio with a little plate left there by Brassaï.

Picasso, it turns out, bought a camera as early as 1904. Vuillard had a Kodak and when he received guests, he always had them pose. Paul Valéry wrote that Degas "loved and appreciated photography at a time when artists disdained it or wouldn't dare admit it existed." He added, "I will never part with one of the enlargements he gave me. Next to a large mirror, you see Mallarmé leaning against the wall, Renoir on a couch sitting across from him. In the mirror, like two ghosts, Degas and his camera. Madame and Mademoiselle Mallarmé catch each other's eye. Nine gaslights, a dreadful fifteen minutes where nobody could budge, were the conditions for creating this kind of masterpiece. I have here the most beautiful portrait of Mallarmé I've ever seen."

But what happens when the artist becomes the model? Nadar photographed Delacroix in 1858 and the painter wrote him: "Monsieur, I am so upset by the result we obtained that I am writing to ask you in the most urgent way and as a favor to me to destroy any prints you may have made of this photo."

As for Nadar, do people know that he started taking photos to help with his caricatures? He heaped sarcasm on the people who became professionals: "Anyone you could think of, in any walk of

life, high or low, was setting himself up as a photographer, from the office clerks who forgot to go back to work the day the bills came due, to the tenor in the music hall who couldn't sing on key, to the concierge overwhelmed with the desire to become an artist—they all called themselves artists! Failed painters, sculptors who'd missed their calling came in crowds—even a cook took a shine to it."

Nadar knew that not anyone could simply become "artistic": "The theory of photography can be learned in an hour; the first ideas of how to go about it in a day. What can't be learned is a feeling for light, the artistic appreciation of effects produced by different light sources, different times of day. What's even harder to learn is an understanding of your subject, an immediate intuition that connects you to your model . . . and allows you to create, not some indifferent reproduction that any lab slave might produce arbitrarily and without tact, but rather the most familiar, favorable and intimate likeness."

In Exile

"THE ART OF PHOTOGRAPHY is the great expressionist art form of our times," claimed Pierre Mac Orlan. "At the same time it's a good line of work, involving ruses and charming naiveté." He also said, "A mix of hereditary candor and filth acquired through contact with people gives that bothersome witness, the photographic lens, such a range of experiences and conclusions that a family photo album becomes something more moving than nature itself, because it is a source of complicity with people."

If I open my old photo albums, my companions from the past, most of them dead now, look back at me. Some days it gives a sad kind of pleasure, and then other days, the same activity brings me face to face with nothingness. So many of the men, the women, were young and charming, truly beautiful. They will never be old. Soon it becomes intolerable to realize that they're in a tomb or reduced to ashes. I close the album.

When I look at those photos from the past, I have the impression that the present is a foreign country. I live here in exile.

The Swan Song of the Olympus

MY ROLLEICORD WAS STOLEN in the Cairo airport. Unless it was some other camera. I can't remember anymore.

One of the cameras that accompanied me for many years when I went back to photography, after the hiatus because of journalism, was a rather large Olympus.

In Saint Petersburg, thanks to a special favor arranged by my friends the Saint-Hippolytes, I had myself photographed at the desk where Dostoyevsky wrote *The Brothers Karamazov*. I didn't push my imitation to the limit, since the same room held the dark-colored couch on which he died.

The next day, getting out of a rowboat after a trip down the Neva, I took a fall and the Olympus was destroyed. In taking my picture sitting, indignant, in Dostoyevsky's chair, my camera must have thought it could never do any better.

Of Dogs and Goats

FOR TEN YEARS I MOSTLY photographed my dog Ulysses, a big
pointer, white with orange spots, golden eyes. He got accustomed
to it and struck his own poses. One day on the little island of
Torcello, at the tip of the Venetian Lagoon, we were walking down
the canal and he saw a wedding party assembled on a bridge. He
ran off and sat himself down in the middle of the group, facing
the camera.

I also enlisted Dick, a retriever, the dog of my adolescence. He
too would pose without being asked. I've kept a quite beautiful
photo where he is lying in a big armchair, his favorite spot, with
his head on the armrest.

Another image. This took place one summer in the Alps. My
son Nicolas was six. Half amused, half frightened, he was sur-
rounded by a herd of goats. No matter how close they came, no
matter how much they nudged him with their snouts and even
shoved him a little, he didn't let go of his camera.

Dick in his favorite chair (Pau, 1935).

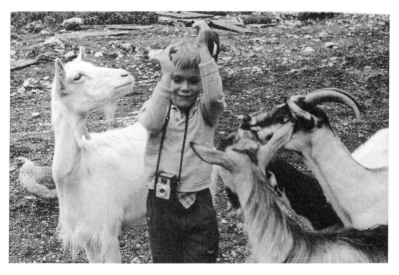

Nicolas with goats in the Alps (Savoia, 1962).

The Dialectic of the Portrait

MOST PEOPLE STORE their photos in a box, often a shoebox. I put mine in albums. Gluing photos into an album is a form of autobiography. Sometimes, though, I get upset as I turn a page. I can't remember where a photo was taken. Or worse, I don't recognize the people. Yet they were important enough for me to include them in the album. I should have written their names on the back, which I was often too lazy to do. In that way I robbed myself of pieces of the past. For a photo is first and foremost a personal souvenir. Even the one of me taken by Edouard Boubat, which is supposed to be a portrait. It reminds me of the morning Boubat visited me with his two Leicas, of the way he stopped in front of the shelf where Chekhov's books were lined up, then in front of the window onto the balcony that was open because it was one of the first days of spring.

Germaine Krull, who excelled in photos of nudes as well as of metal structures, wrote, "In one click of the shutter, the lens records the world externally and the photographer internally." After Boubat took her portrait, Isabelle Huppert remarked: "It's his history, but it's also mine." Lamartine had already said, "Photography is the photographer."

Portraits of writers are often pretexts for a game. You ask the model to comment on the result, to write about how he sees himself according to the image the photographer drew from him. Thus there are collections of photos by Edouard Boubat and Claire Garate accompanied by delicious, even judicious commentary. "Of course you recognize yourself," Dominique Aury writes, for example. "But who is it you recognize?" Just as I hide behind my dog Ulysses, Tonino Benacquista poses behind his cat. Hector Bianciotti thinks that the photographer's task is in vain: "Whoever he photographs is an unknown." Some people like their faces; many don't. And then, perhaps it's the rule of the game; whether or not you like your image, a photograph always produces an intense curiosity. René de Obaldia quotes Georg Christophe Lichtenberg's aphorism: "There is no more fascinating surface on the earth than the human face."

If I examine the photo Boubat took in my apartment, the first information it gives me is about its creator. I see everything that Boubat understood. It's no accident that he placed the dog, Ulysses, in the foreground, to help me hide a little, or at least hold back, which is always my first tendency. It's almost an invitation to describe the fine head of the hound and neglect the human one. So much could be said about the dog standing on his hind legs to contemplate the spectacle of the street and the world over the balcony. About the calm look in his clear eyes. About his youth, the way he plays the wise old dog. The photographer's art lets us decipher the dog's expression, just as it suggests a meaning for the man's face in the background. You think you understand everything, that you've figured out everything, know everything. The art of the portrait is close to that of the novel. In its own way, it proposes a story. It liberates the imagination. If I didn't know the two characters and the decor so well, I would invent a story about the balcony, the sky, the buildings, the man's gray hair, and the dog's white coat. It's one of my favorite games, on one condition: it has to be about the images of others.

Diane Arbus writes, "Everybody has that thing where they

Edouard Boubat's
photo *Roger Grenier
and Ulysses* (Paris, 1973).
Photograph: Getty
Images.

need to look one way but they come out looking another way."
She insists that Kafka's story "Investigations of a Dog" describes
something she was never able to photograph and that is like a
photo for her.

But above all, she declares, "A photograph is a secret about a
secret."

TRANSLATOR'S NOTE

ROGER GRENIER'S MEMOIR of a life spent in the company of photos also chronicles a century of photographic practice. For readers who are interested in the photographs and the photographers in these pages, what follows is a selection of the books and essays he describes. For material cited by Grenier from these and from other works of literature, I've quoted the existing English-language editions of the works, and translated from the French when an English-language translation doesn't exist.

Diane Arbus. *An Aperture Monograph*. Edited by Doon Arbus and Marvin Israel. New York: Aperture, 2007.

Charles Baudelaire. "The Salon of 1859." In *Selected Writings on Art and Literature*. Translated by P. E. Charvet. New York: Penguin, 1972.

Edouard Boubat. *Edouard Boubat: The Monograph*. New York: Harry N. Abrams, 2004.

———. *A Gentle Eye*. Edited by Bernard Boubat and Genevieve Anhoury. London: Thames and Hudson, 2004.

Brassaï. Introduction by Lawrence Durrell. New York: Museum of Modern Art, 1968.

Brassaï. Introduction by Roger Grenier. New York: Pantheon Books, Centre National de la Photographie, 1988.

Brassaï. *Conversations with Picasso.* Translated by Jane-Marie Todd. Chicago: University of Chicago Press, 1999.

———. *Henry Miller: Happy Rock.* Translated by Jane-Marie Todd. Chicago: University of Chicago Press, 2001.

———. *Proust in the Power of Photography* Translated by Richard Howard. Chicago: University of Chicago Press, 2001.

Julia Margaret Cameron. *Victorian Photographs of Famous Men and Fair Women.* Introduction by Virginia Woolf and Roger Fry. London: The Hogarth Press, 1973.

Henri Cartier-Bresson. *Henri Cartier-Bresson: The Modern Century.* Edited by Peter Galassi. New York: Museum of Modern Art, 2010.

Henri Cartier-Bresson and André Pieyre de Mandiargues. *Photoportraits.* London: Thames and Hudson, 1985.

Alfred Eisenstaedt. *Eisenstaedt on Eisenstaedt: A Self-Portrait.* Introduction by Peter Adam. New York: Abbeville Press, 1985.

Maria Morris Hambourg, ed. *Félix Nadar.* New York: Metropolitan Museum of Art, 1995.

André Kertész. *Kertész on Kertész: A Self-Portrait.* Introduction by Peter Adam. New York: Abbeville Press, 1985.

Germaine Krull. *Germaine Krull: Photographer of Modernity.* Cambridge: MIT Press, 1999.

Antony Penrose. *The Lives of Lee Miller.* New York: Holt, Rinehart and Winston, 1995.

———. *Lee Miller's War.* Boston: Little, Brown, 1992.

Félix Nadar. *Quand j'étais photographe.* Paris: Actes Sud, 1999. Translation by Eduardo Cadava forthcoming from MIT Press.

Paul Nadar. *The World of Proust: As Seen by Félix Nadar.* Cambridge: MIT Press, 2002.

Willy Ronis. *Photographs 1926–1995.* Oxford: Museum of Modern Art, 1995.

———. *Ce jour-là.* Paris: Mercure de France, 2006.

Jeanloup Sieff. *Jeanloup Sieff, 1950–1990: Time Will Pass Like Rain.* Cologne: Taschen/Evergreen, 2010.

Susan Sontag. *On Photography.* New York: Farrar, Straus and Giroux, 1973.

Paul Strand. *La France de Profil.* Text by Claude Roy, translated by Marjolin de Jager. New York: Aperture, 2002.

Roger Taylor. *Lewis Carroll, Photographer*. Princeton, NJ: Princeton University Press, 2002.

Michel Vanden Eeckhoudt. *Zoologies*. Text by Claude Roy. Paris: Editions Delpire, 1982.

Weggee [Arthur Fellig, pseud.]. *Weegee by Weegee: An Autobiography*. New York: Da Capo Press, 1975.

Émile Zola. *Carnets d'Enquêtes* [His notebooks and photographs]. Edited by Henri Mitterand. Paris: Plon, Terre Humaine, 1986.

TRANSLATOR'S ACKNOWLEDGMENTS

MY THANKS first of all to Roger Grenier, who worked closely with me on this translation. I thank Mary Ann Caws, the Press's reader, and Lydia Cochrane, the Press's vettor. I am grateful to Laura Marris for her fine reading and suggestions on a penultimate draft. My thanks go as well to Alan Thomas, editor and photographer, for his expertise.